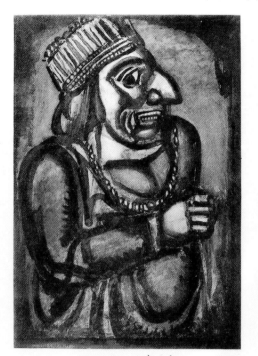

nous croyant rois.

S'RUVOUR

Great Modern Masters

Rouault

General Editor: José María Faerna

Translated from the Spanish by Alberto Curotto

CAMEO/ABRAMS

HARRY N. ABRAMS, INC., PUBLISHERS

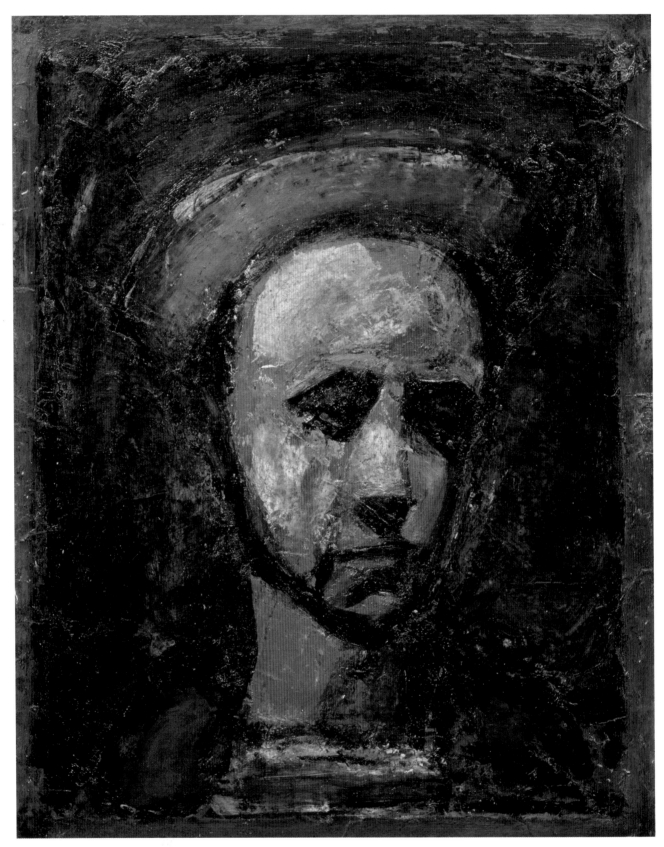

The Workman's Apprentice (Self-Portrait),
c. 1925. Oil, 26 × 20½" (66 × 52 cm).
Musée National d'Art Moderne, Centre
Georges Pompidou, Paris

Rouault's Loyalty to His Inner Vision

"**I**am obedient. Just about anybody can be a rebel: it is a much more difficult undertaking to obey silently the dictates of one's soul and to spend one's life looking for the truest means to express one's temperament and talents." This statement provides the key to understanding the life and artistic achievement of Georges Rouault, one of the most singular figures in the history of modern art. In his unwavering loyalty to what he called his "inner vision," Rouault always kept to the shallows of the aesthetic currents that rapidly washed one over the other during the early decades of the twentieth century. Fanatically jealous of his solitude, Rouault produced a body of work that fails to fit any of the customary categories.

A Personal Revolution

Rouault's paintings were shown beside those of Henri Matisse and Albert Marquet—artists who, like Rouault, were disciples of Gustave Moreau—at the famous Salon d'Automne of 1905. The painters who exhibited their brilliantly colored pictures there were called "wild beasts" (*fauves*, in French) by the critics, but Rouault's bitter symbolism can hardly be called Fauvist. By the same token, his serene disposition and meticulous technique are quite alien to the state of nervous agitation that characterizes the works of the contemporary German Expressionists. It is of little value to place Rouault within a hypothetical French Expressionist school since he would be its sole representative. As the "originator of a personal revolution," according to the definition of one critic, Rouault soon comprehended the need to reconcile his painting with his personal beliefs. After the death of Moreau—a teacher who conscientiously cherished and respected the unique personalities of his pupils, and who prophesied for Rouault a solitary career—the young painter decided to abandon Symbolism in order to direct his undivided attention to the spectacle of human misery. His choice was quite unlike that of the *fin de siècle* Symbolist writers, who shielded themselves from that same spectacle by looking inward and exploring their psyches. Gradually, the religious and working-class figures that people Rouault's works at the outset of his career gave way to clowns, prostitutes, and shady-looking characters. As he painted these new motifs, Rouault's style lost its distinctive formal exactitude and gained a remarkable degree of expressive intensity—a risky alteration in course for a painter who had already achieved conspicuous success with his early religious compositions. It earned him the accusation of "wasting his natural talent only to immerse himself in ugliness."

Expressive Sincerity

In view of this change, we need to examine more carefully the adjective "obedient" that the artist ascribed to himself in the quotation that opens this book. At the beginning of his career, when his quest for artistic purpose was most urgent, Rouault was hardly acquiescent: his work, fundamentally at odds with the prevailing taste of his age, broke violently away from the academic tradition and became attuned to the most radical movements of the early twentieth century. Having found his own voice—

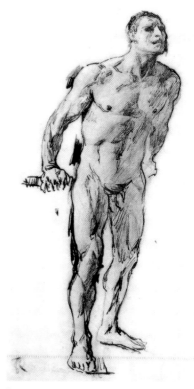

Preparatory drawing for The Ordeal of Samson, *the work that Rouault submitted as his official entry in the Prix de Rome competition of 1893*

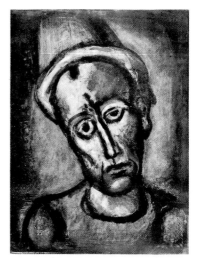

Qui ne se grime pas?

Don't We All Wear Makeup? *1917–27. The title of this etching from Rouault's famous series* Miserere *bespeaks the artist's visceral rejection of falsehood and hypocrisy.*

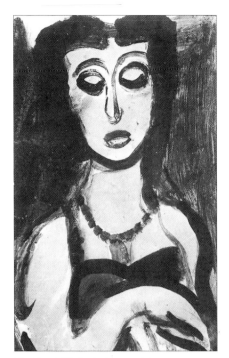

The Stuck-Up Lady is one of the many characters in the gallery of types that Rouault produced between 1910 and 1920. With their ironic and rather humorous air, these lesser works constitute an exceptional group in the painter's total output.

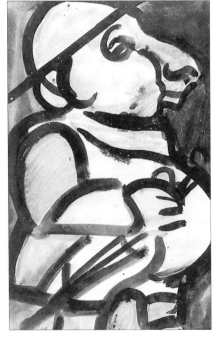

This is one of a number of works in which Rouault portrayed Father Ubu, a grotesque character created by Alfred Jarry as the protagonist in a series of plays that anticipate the Dada movement and the Theater of the Absurd.

"the truest means to express one's temperament and talents"—the artist remained loyal to his own inner vision. For more than fifty years, until his death, he ignored the momentous changes in style that rocked the art world. Rouault proved equally nonconformist when it came to the artist-client relationship: despite his heartfelt belief in the intrinsic worth of handmade objects, his decision in 1947 to publicly set fire to a number of works that he had finally recovered from the heirs of his agent after a decade of lawsuits constituted a landmark in the history of the struggle of artists to claim their rights to their own work.

A Christian Artist

A reference to handicraft is not unwarranted when speaking about Rouault, who felt it was preferable to be a good artisan than a sloppy or hypocritical fine artist. The high regard in which Rouault held skillful craftsmanship was formed during his boyhood apprenticeship to stained-glass artists. In part, it must also have been a legacy of his father, a cabinetmaker and a varnisher of pianos who was known to be galled even by a squeaking door, "as if wood itself were being made to suffer." A lover of his own trade, Rouault approached painting with a degree of meticulous determination that seems to belie the ecstatic and gestural aspect of his production. In spite of his uncompromising individualism as an artist, his style does possess a certain folk quality, which explains why so many of his paintings, especially those with religious themes, seem to have issued from the brush of some anonymous early Christian artist. Rouault held profound religious beliefs throughout his entire career, and they further set his work apart from that of his contemporaries. The Christian quality of his painting is manifested both in his choice of themes and in his attitude toward life. Thus, Rouault found himself concurring with his close friend the philosopher Jacques Maritain, who thought that Christian art was defined by the individual in whom it developed, and that within that individual it was impossible to distinguish the artist from the Christian.

The Language of Sorrow

Rouault's entire production, even his works with secular themes, is pervaded by the same religious spirit that—in Maritain's words—can manifest itself in a symphony, a ballet, or a novel, as well as in the stained-glass window of a cathedral. Rouault always maintained an exceptionally close and often painful contact with life: his works depict human beings, not metaphysical entities, and his characters—whether he drew them from street life or whether they issue from the Christian legend—all speak the same language of sorrow and suffering. His stark and somber idiom is very unlike that of the serene, almost childlike holy pictures by the seventeenth-century French Pietist painters. Underneath Rouault's expressive choices, there lies a sense of allegiance to the real world that the artist summed up in these lines, published in a review in 1944: "I don't believe in vague and tremendous theories or ideas about the otherworld since, in practice, they are lifeless and not viable. I abhor such wanderings of thought and action. They can only culminate in a soggy and facile idealism which, in its arrogant attempt to explain and sort everything out, ends up blunting the edges and wearing the fabric until it becomes threadbare. Holding such bland softening in horror, I much prefer cynicism, and even the most grotesque or violent form of realism."

Georges Rouault/1871–1958

Georges-Henri Rouault was born, in 1871, in a cellar on the rue de la Villette in Paris, where his mother had found shelter from the artillery shelling by the troops of the conservative National Assembly, which were making their way into the city in order to quash the republican Commune. From his father, a humble cabinetmaker employed in a piano factory, Rouault inherited an artisan zeal for a job well done. His grandfather on his mother's side bequeathed to him an admiration for such modern painters as Gustave Courbet, Honoré Daumier, or Édouard Manet. At age fourteen, Rouault became an apprentice in a stained-glass workshop. About the same time, he began attending evening classes at the École des Arts Décoratifs, where he learned to draw. In 1890, having decided to devote himself entirely to fine arts, he enrolled at the École des Beaux-Arts in Paris, where he studied first under the direction of Élie Delaunay, an academic painter, and later under the Symbolist painter Gustave Moreau. The progressive teachings of Moreau, his open-mindedness and lack of prejudice, afforded his pupils—who, besides Rouault, included Henri Matisse and Alfred Marquet—the opportunity to develop freely their individual artistic tastes and ideas.

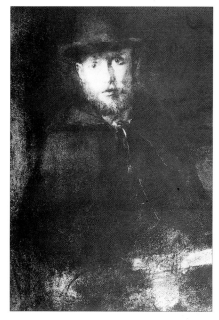

The artist made this charcoal self-portrait in 1895, when he was twenty-four years old and about to leave the École des Beaux-Arts, following the advice of his teacher Gustave Moreau.

Moreau's Teachings

Very soon, Rouault became Moreau's favorite pupil. From the beginning, the young artist painted works with religious subjects. For one such painting, *The Child Jesus among the Doctors* (plate 2), Rouault won the Prix Chénavard in 1894, but only after the jury, confronted with fierce protests, reversed its original decision to award the prize to a pupil of Léon Bonnat, a prominent academic painter. The following year, after seeing his ambition to win the Prix de Rome frustrated for the second time, Rouault took his teacher's advice and dropped out of school in order to continue his career independently. This decision, however, did not cause him to sever his ties with Moreau; on the contrary, the young painter continued to pay frequent visits to his former teacher, whom he kept informed as to his own progress by showing him the works that he was painting. Moreau's death, in 1898, signaled the beginning of a difficult personal crisis for Rouault, as well as a radical change in his style of painting. The young artist relinquished his formerly conventional and moderate style in favor of—in his own words—a new "offensive lyricism."

Street Types

In the early 1900s, the transformation in Rouault's work that had begun after the death of Moreau reached its maturity. The change was advanced by Rouault's visit to the abbey of Ligugé—where the writer Joris-Karl Huysmans had planned to found a community of Catholic artists—and, above all, by the long periods that Rouault spent in the beautiful Haute-Savoie region while convalescing from an ailment. Quickened by his immersion in nature, Rouault developed a highly individual expressive style as well as a subject matter that reflects his disgust with the corruption and complacency of bourgeois society. Up to about 1912, he avoided religious themes. Instead, he painted—for the most part, in watercolor and gouache on paper—a heterogeneous array of judges, prostitutes, cir-

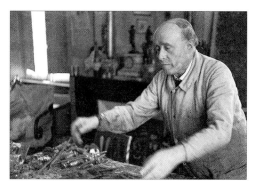

Rouault seldom allowed anyone to take his photograph. Most of the snapshots that exist show the painter at work—like this one, shot in his Saint-Malo studio in 1932.

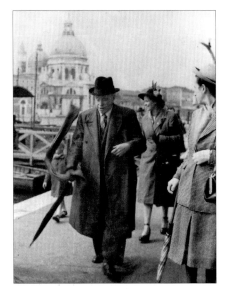

Rouault had little interest in social life and made few public appearances. This photograph shows him in the company of his daughters Geneviève and Isabelle in Venice, where his work was being shown at the 1948 Biennale.

Rouault stands in his studio, already more than eighty years old. His work clothes, which make him look more like a baker than an artist, invoke the artisan—an aspect of his trade that Rouault had always wished to stress.

cus people, and street types. During those years, Rouault—who had been appointed curator of the recently inaugurated Musée Gustave Moreau—regularly exhibited his works at the Salon d'Automne, of which he had been one of the founders, as well as at the Salon des Indépendants. In the same period, he became a close friend of such prestigious intellectuals as the Catholic writer Léon Bloy or Jacques Maritain. In 1908, Rouault married Marthe Le Sidaner, a sensitive and cultivated woman and a first-rate pianist, who remained at the painter's side for the rest of his life.

The Contract with Vollard

During the second decade of the twentieth century, Rouault began to paint heavier forms outlined with thick black lines; watercolors and gouache gradually gave way to oils, which can be applied in thick, heavy brushstrokes. At the same time, he became an accomplished engraver, producing such important works as *Miserere et Guerre* (Mercy and War), a series he executed between 1917 and 1927 but which was first published in 1948 under the title *Miserere*. In 1917, Rouault signed an exclusive contract with Ambroise Vollard, whom he had first met ten years earlier. According to the terms of this agreement, the famous art dealer acquired rights to the artist's entire life's work—including the over seven hundred pieces in his studio at the time. This enabled Rouault to devote himself exclusively to his artistic activity. Rouault established his workshop on the top floor of Vollard's house and a long, productive period ensued, but following the art dealer's death in a car accident in 1939, his heirs sealed the entrance to the artist's studio, preventing him from recovering the numerous notes and sketches that Rouault considered as the essential tools of his trade as a painter.

A Moral Victory

Around 1918, religious subjects, especially depictions of Christ, assumed a prominent role in Rouault's work. His brushstrokes became heavier; thick with paint, his pictures increasingly came to look like painted bas-reliefs. Though he deliberately ignored the many artistic currents that unfolded in the first half of the century, Rouault enjoyed considerable prestige during the last decades of his life: in 1925, he was made Chevalier of the Legion of Honor and, starting in 1930, exhibitions of his work were regularly held both in France and abroad. His increasing fame was advanced by the settlement of his suit against Vollard's heirs, in 1947. The court ruled that an artist owns his work until he sells or gives it to another person. After many years, Rouault was thus able to recover the greater part of the unfinished works left in his studio (over one hundred were missing). He proceeded to burn, before a notary public, 315 of them, ones he felt he could no longer complete. The artist burned other works for the same reason in the 1950s. This moral triumph appears to have had an impact on his work, which took on warmer tonalities while, at the same time, it lost most of its former dramatic quality. Rouault's last years unfolded in a contented and happy environment. In 1956, he became too feeble to paint. He died in 1958, at the age of eighty-six. Soon after his death, his family donated more than eight hundred of his unfinished works to the French state.

Plates

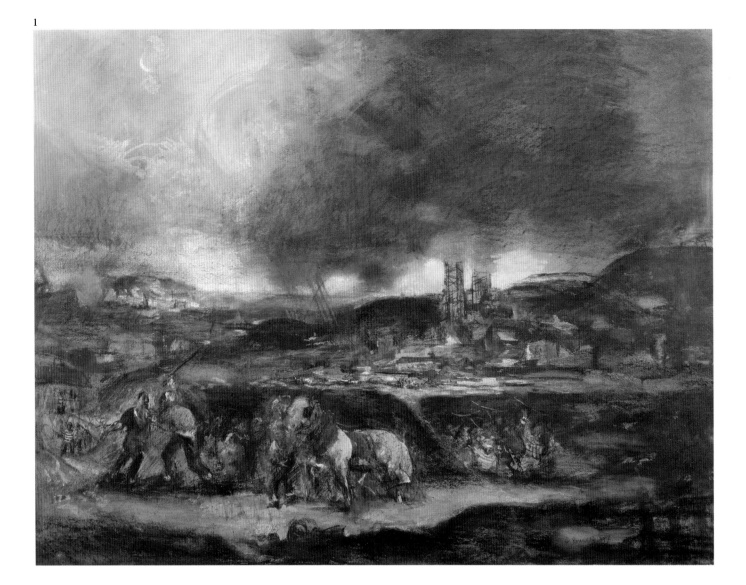

Under Moreau's Guidance

While Rouault's early paintings show a considerable number of different influences, the prevailing ones come from the works of Albrecht Dürer, Rembrandt, and the French still-life artist J.-B.-S. Chardin. Guided by his teacher Gustave Moreau, the young Rouault was able to assimilate the art of these and other masters in the rooms of the Musée du Louvre. The influence of Moreau was a crucial factor in Rouault's artistic evolution. Though the young artist borrowed few specific formal ideas from Moreau, he flourished in the favorable environment that Moreau was able to create in his classes by encouraging the specific talents and choices of each one of his students. It was just such open-mindedness that led the old Symbolist painter to advise his most outstanding pupil to drop out of the École des Beaux-Arts in order to paint independently. Rouault heeded his teacher's advice and launched a career that would forever be characterized by the most uncompromising independence. After Moreau's death, Rouault's estrangement from a school environment precipitated a radical transformation in his work. This crucial change of direction was keenly criticized by his friend Léon Bloy, who had been fascinated by Rouault's early works, such as *The Child Jesus among the Doctors* (plate 2). Bloy pronounced it "lamentable that an artist . . . competent to paint seraphim [was now able] only to conceive abominable and vindictive creatures." The Catholic writer was referring scornfully to Rouault's new subject matter: prostitutes, mountebanks, clowns, and the hard-boiled members of the legal profession.

1 Night Landscape (The Workyard), *1897. This strange and gloomy scene is among the many landscapes Rouault painted during his career. It reflects the Symbolists' tenet that a painting should express emotions. In a quarry, under a stormy sky, a brutal fight is taking place. The harsh contrasts of light and dark and the use of somber tonalities enhance the dramatic and disturbing character of a scene that cannot fail to evoke Francisco Goya's work.*

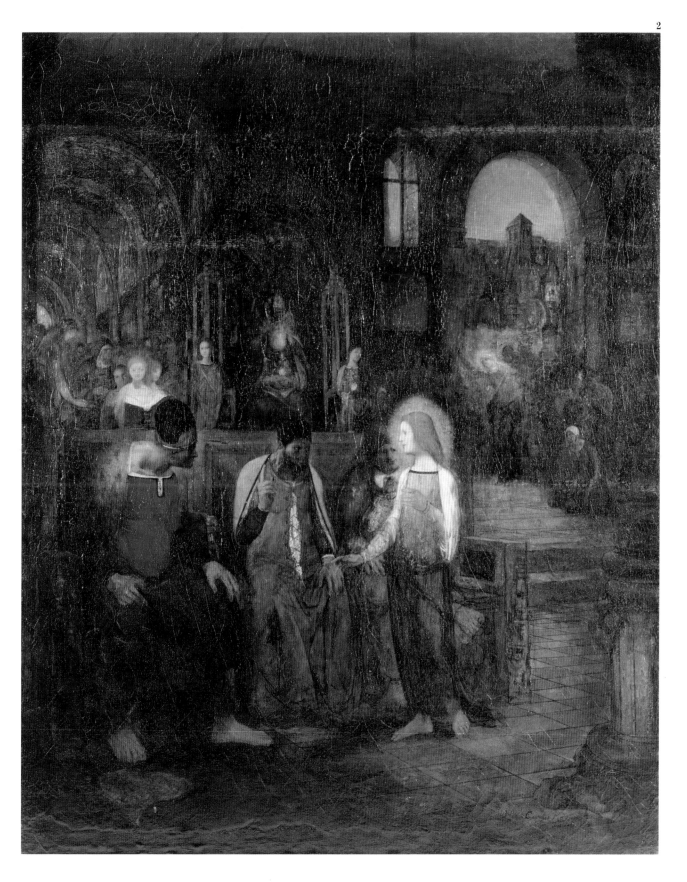

2 The Child Jesus among the Doctors, *1894. This painting, which earned its author
the Chénavard prize, was Rouault's first important achievement. It quite clearly
reveals the influences that were shaping the young painter, including the work of his
teacher Gustave Moreau, as well as that of other great painters—such as Eugène
Delacroix, Théodore Chassériau, or Rembrandt—whom Moreau used to praise in his
conversations with his pupils. This was the first painting by Rouault acquired by the
French state—in 1917, when the artist's style was far removed from the daintiness of
this early picture.*

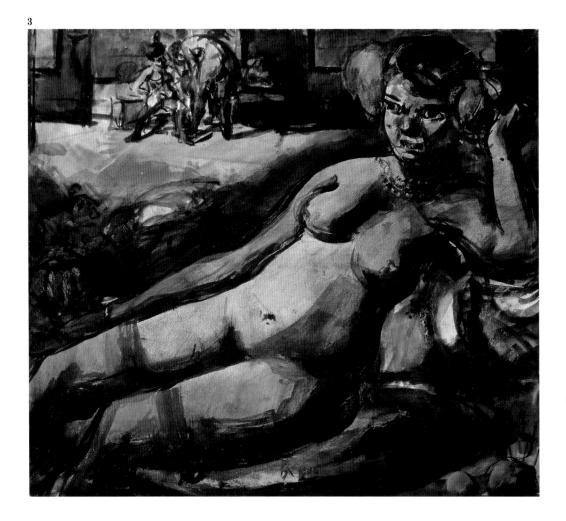

3 Odalisque, *1906. This odalisque—the Turkish word means female slave in a harem—has very little in common with the exotic courtesans who, beginning with Delacroix, had peopled canvases by nineteenth-century French painters. The cold blue light that envelops Rouault's figure, her coarse features and squint, and the cadaverous quality of her flesh suppress any suggestion of sensuality. In depicting this woman, Rouault evokes the squalor of her existence, which lacks any trace of glamour.*

Nudes and Prostitutes

The female body played a very important role in Rouault's work, especially between 1902 and 1914. Some paintings on this theme can be called nudes; others are depictions of prostitutes, showgirls, and acrobats. The nude studies reveal no ethical or social preoccupations (see plates 4, 6, 8), but Rouault's portrayals of marginalized women are tinged with an urgent and profound sense of sympathy (see plates 3, 5, 7). Rouault never judges his subjects, nor does he gibe at their deplorable circumstances; he does not aim at revealing their modernity or at shocking bourgeois morality by boldly depicting lewd motifs. Convinced as he was that "behind the eyes of the most hostile, ungrateful, or impure being dwells Jesus," the French painter commiserates and empathizes with these abused and ill-treated creatures. When Rouault portrays a prostitute, as the critic Louis Vauxcelles once said, "he does not cruelly rejoice, as Toulouse-Lautrec did, at the vice that the girl arouses; instead, he suffers and weeps for it."

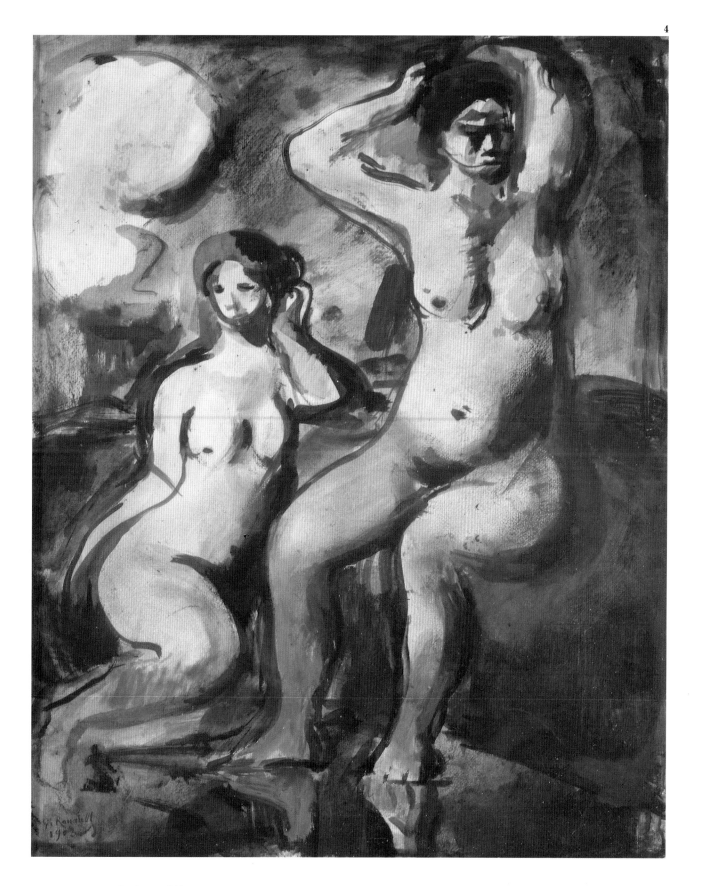

4 Bathers, *1903. The profound admiration that Rouault felt for Paul Cézanne is openly proclaimed by the palette of deep blue tones in which he chose to paint these two magnificent nudes. Rouault painted this watercolor three years before* Odalisque *(plate 3). Whereas the blues that tinge the odalisque's flesh are cold and dead, the blues in the present picture render the women's bodies luminous. A thick, uninterrupted stroke reveals the sinuous outlines of each torso and thigh. The simplicity of means that characterizes* Bathers *is rare in Rouault's pictures dating from the first decade of the twentieth century, which are generally built up on an intricate pattern of brushstrokes.*

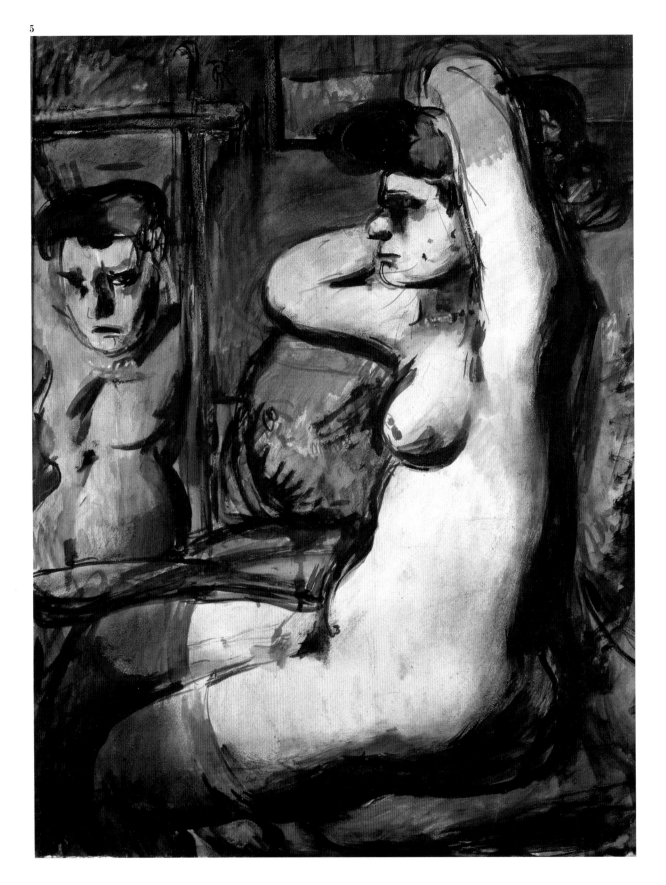

5 Prostitute at Her Mirror, *1906. This is possibly the most intense of all the pictures of prostitutes that Rouault painted between 1902 and 1914. Rouault has shown a prostitute in the privacy of her bedroom, but unlike Edgar Degas or Henri de Toulouse-Lautrec, who painted many similar pictures, he is not a dispassionate observer. He underscores the woman's individuality by showing her sad and defiant countenance reflected in the mirror. The expressive effect of this device is enhanced by Rouault's rejection of traditional perspective, as well as by his suppression of anything that might suggest a story.*

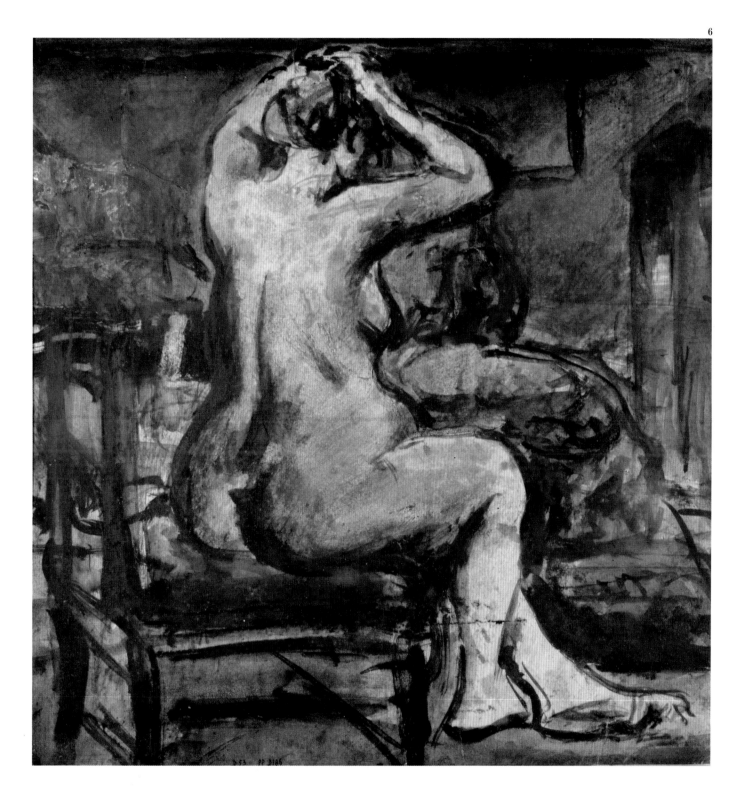

6 Nude with Arms Raised (Combing Her Hair), *1906. This is one of the rare nudes by Rouault in which the figure is shown from the back. The fact that we cannot see the model's face suggests that the artist's intentions were purely formal. In this carefully worked out study, Rouault has given us a (for him) unusually vital and sensual interpretation of the female body.*

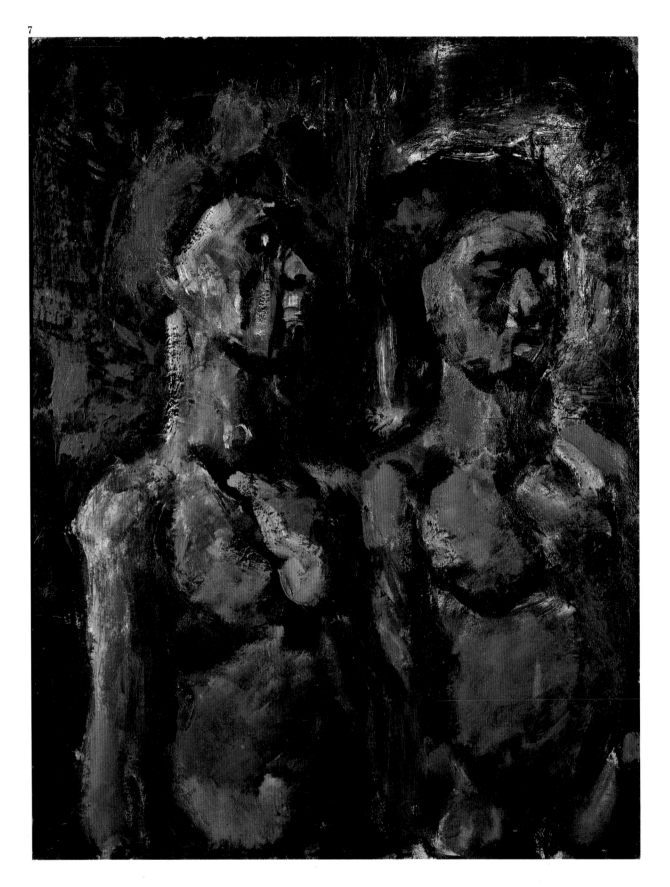

7 Prostitutes, *c. 1909. In discussing the intensity of images such as this, the critic Bernard Dorival—a scholar of Rouault's work—once wrote: "Everything that whores represented for him—namely, the basest dishonor, the most bestial obscenity, the alienation of the spirit trammeled by matter, temptation, and sin, but also pain and shame—Rouault was able to translate visually into their disgusting bodies and even more repulsive countenances."*

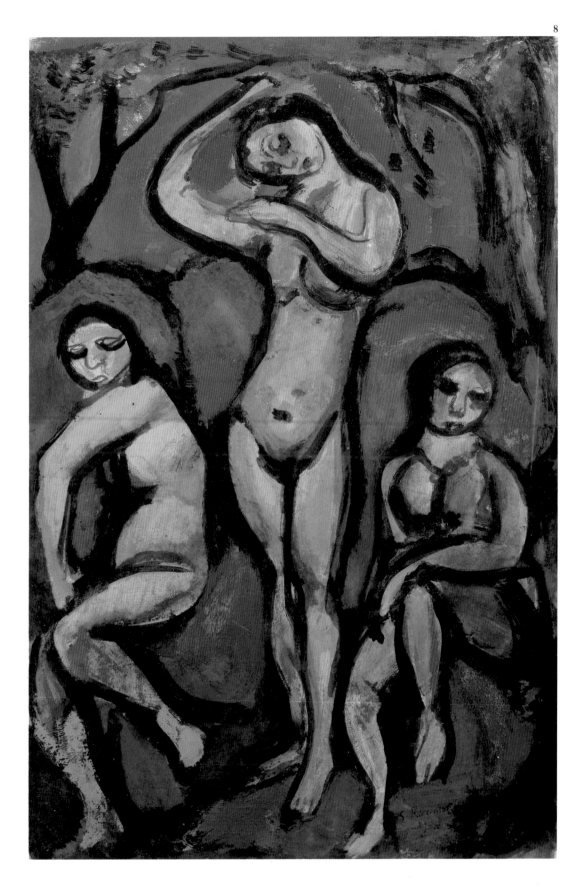

8 Nudes, *1914. Ten years later, Rouault's nudes recovered the tranquillity that they possessed at the beginning of the century. The outlines of torso and limbs are once again traced with thick and sinuous strokes, while skin tones become lighter and the flesh loses its former lifelessness. The artist's renewed sense of equanimity is here underscored by the balanced triangular composition, which may reflect Cézanne's influence.*

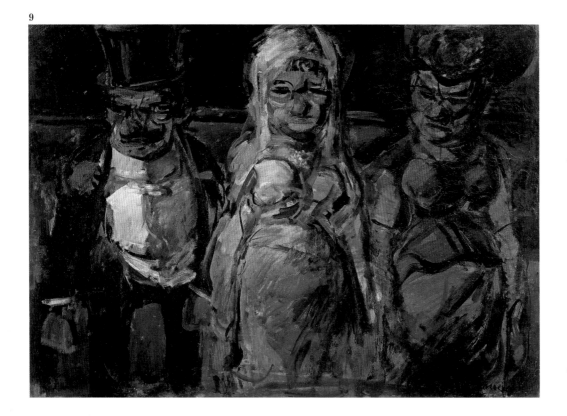

9 Pitch-Ball Puppets (The Bride), *1907. The unusual subject of this oil painting is a group of puppets of the type that visitors to a fairground throw balls at, with the aim of tipping them over and perhaps winning a prize. Because they are puppets, Rouault emphasized the grotesque qualities of these figures, but their general aspect does not differ much from that of his living subjects. The reason for this lies in one of the painter's strongest convictions: in human terms, it is impossible to distinguish the assailant from the victim or the executioner from the convict.*

The Circus of Life

Rouault felt a very special attraction to the circus and its people. In a letter dated 1905, the painter described a personal encounter with this world: "The wagon of nomads halted in the middle of the road, the tottery old horse grazing the sparse grass, the old clown in a corner of his wagon mending his shiny and no longer motley costume; the sharp contrast between shiny, glistening things that are meant to amuse and this exceedingly sad life, at least when observed from afar. . . . Later on, I clearly realized that the clown was myself, he was all of us, almost all of us." As these lines suggest, circus motifs did not offer Rouault a pretext to develop elaborate effects of light, color, or motion, as they did such artists as Degas, Toulouse-Lautrec, or Georges Seurat. Rouault's intentions in depicting circus life were to portray and reveal the sad circumstances of individuals who, under the makeup and the sequined costumes, are really suffering even when they appear to be laughing—and incidentally to suggest that, just like the clowns, we all hide behind our own personal masks. Rouault does not usually portray these characters in the bright circus spotlights; most often removed from the vivaciousness of the ring and lonely, they are presented to the viewer as symbols of the inescapable misery of the human condition.

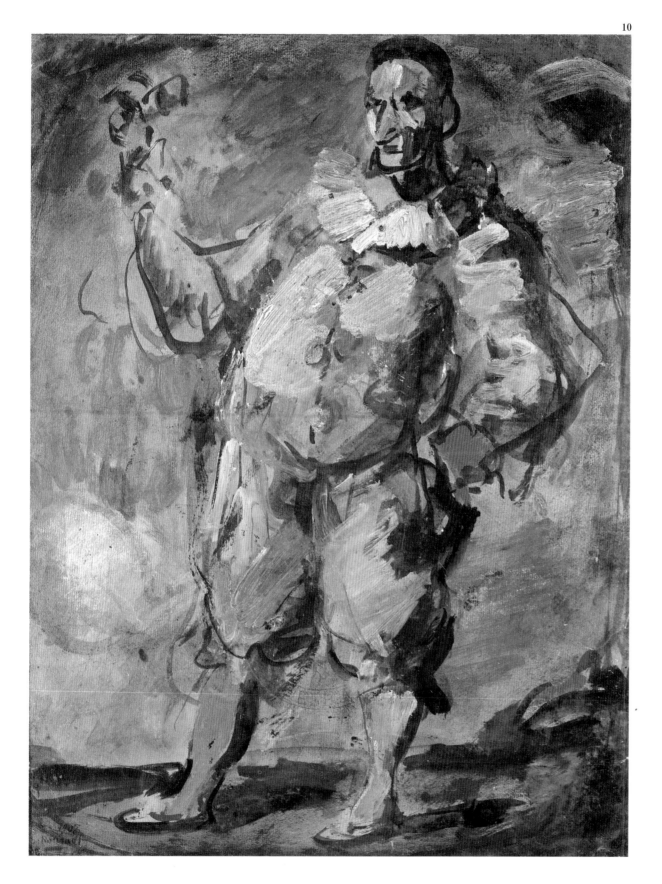

10 The Conjuror (Pierrot), *1907. Unlike most of Rouault's clown subjects, this one is depicted standing and at full length; moreover, the vivid colors and the confident, carefree gesture convey a cheerful view of the character, who—also quite unusually— is depicted in performance.*

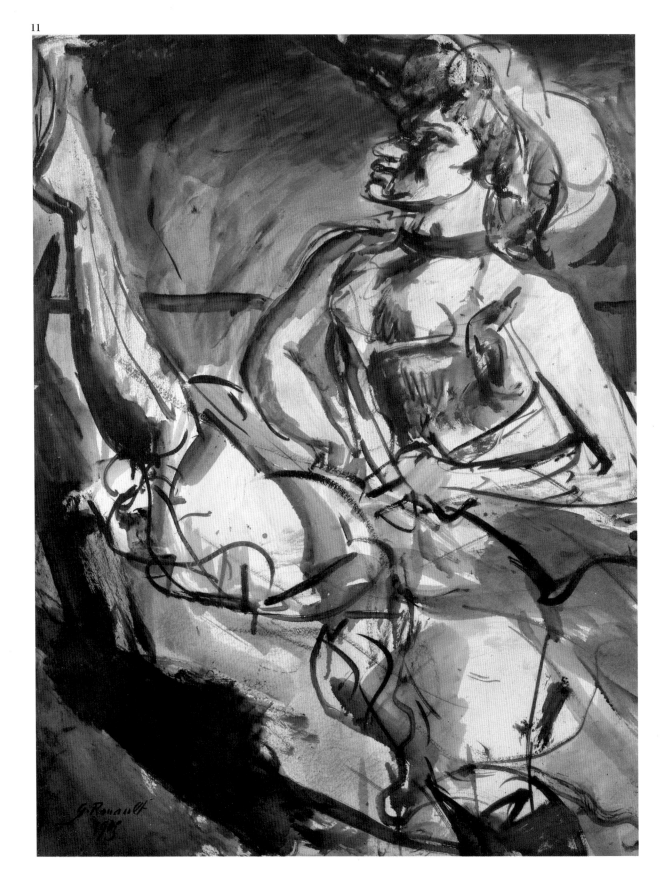

11 Bal Tabarin (Dancing the Chahut), *1905. This is one of the rare instances in Rouault's work where the subject is depicted in vigorous motion. Like Toulouse-Lautrec and Seurat—who also depicted cancan dancers—Rouault freezes the action at the most acrobatic moment, underscoring the dynamism of the dancer's position by means of a series of thick lines traced with slashing and skittish strokes of the brush.*

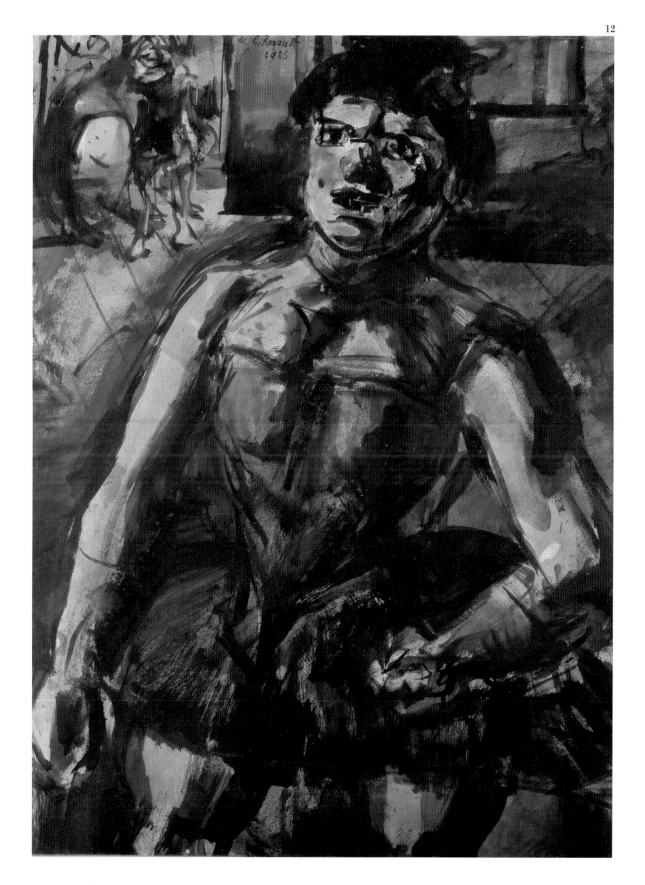

12 The Equestrienne (The Female Clown), *1906. In Rouault's work, while male clowns invariably have an aura of somber dignity, female clowns are almost always grotesquely ugly. This did not go unnoticed. In his review of the paintings Rouault exhibited at the 1906 Salon d'Automne, one critic spoke of the artist's "paradoxical misogyny."*

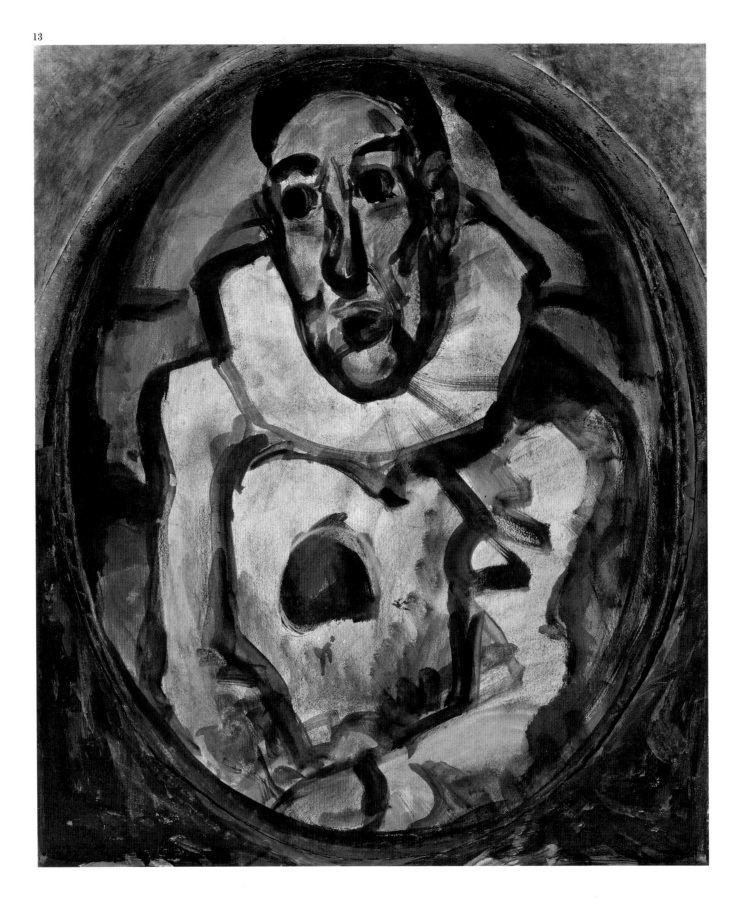

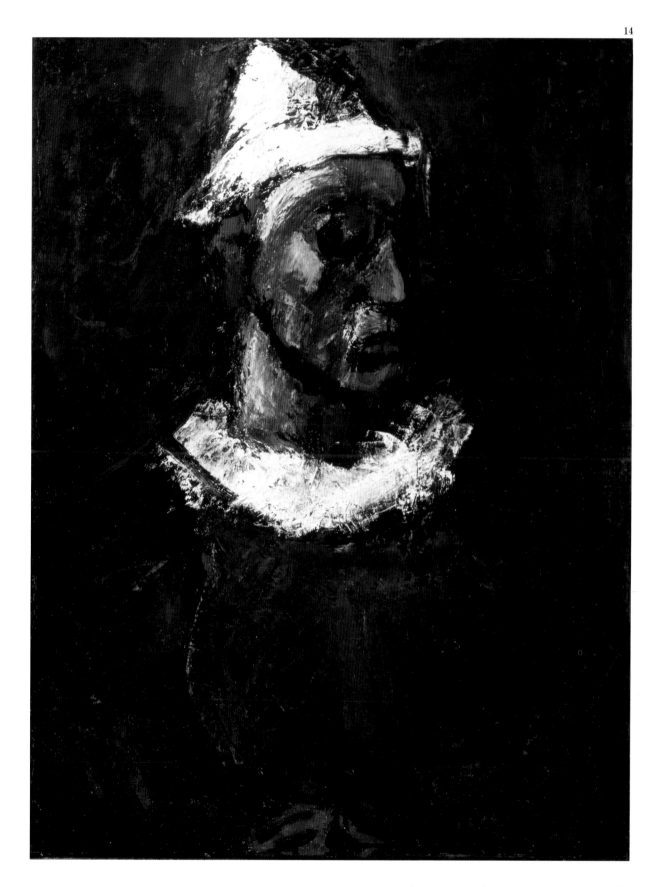

13, 14 White Pierrot, *1911;* Clown, *1912. These two works, painted barely a year*
apart, illustrate the transformation that took place in Rouault's style around 1912.
White Pierrot *is painted with fluid brushwork and swift strokes of pastel; in* Clown,
thick oils unevenly applied announce the heavy impasto of the artist's late production.

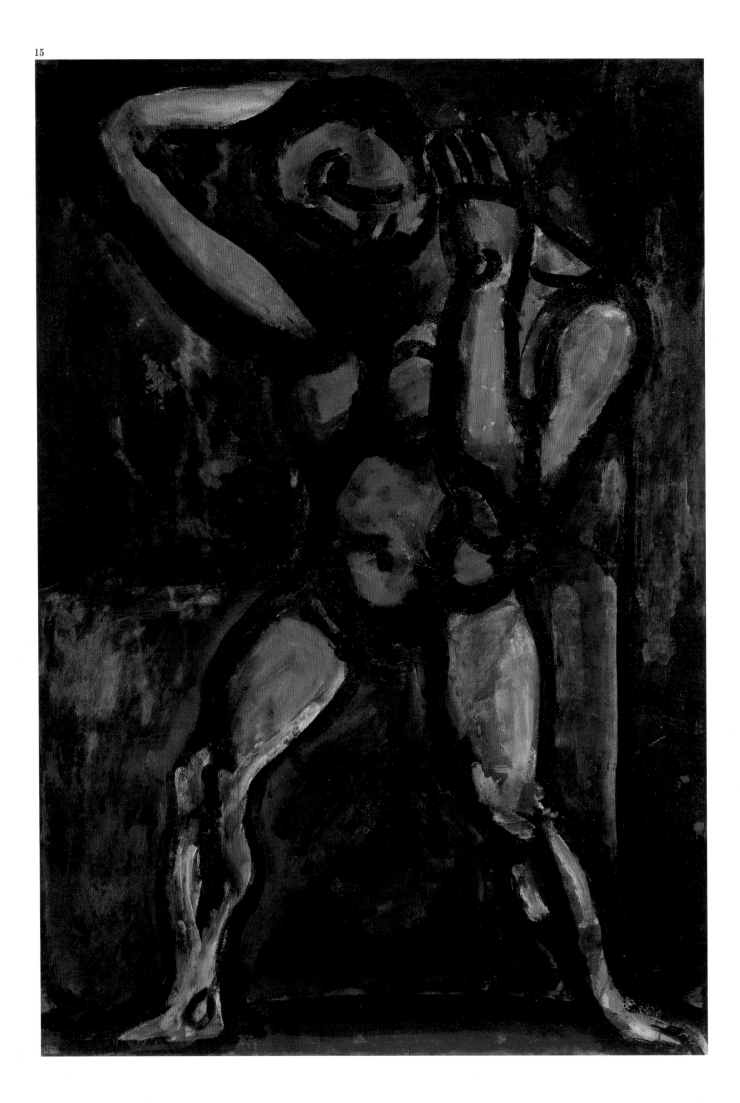

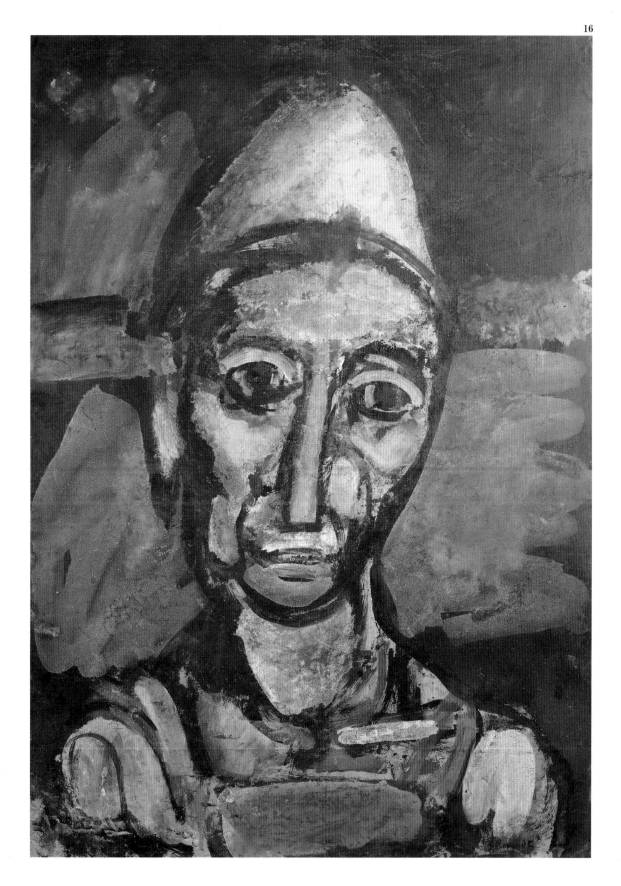

15 Acrobat XVI (Wrestler), *1913. After working for more than a decade with watercolors and gouache, Rouault began to combine water-based paints and oils in his pictures. In the present work, thick strokes of gouache emphasize the outline of the figure, while conspicuous brushstrokes of oil paint specify certain anatomical details.*

16 The Old Clown, *1917–20. "Behind our glittering masks, we all hide a tormented soul, a tragedy": this is the message that Rouault sought to convey in his pictures of clowns. Here neither the whiteness of the makeup and the tiny cap, nor the clown's trimmed and gaily colored outfit can hide the model's wrinkles or his infinitely sad eyes.*

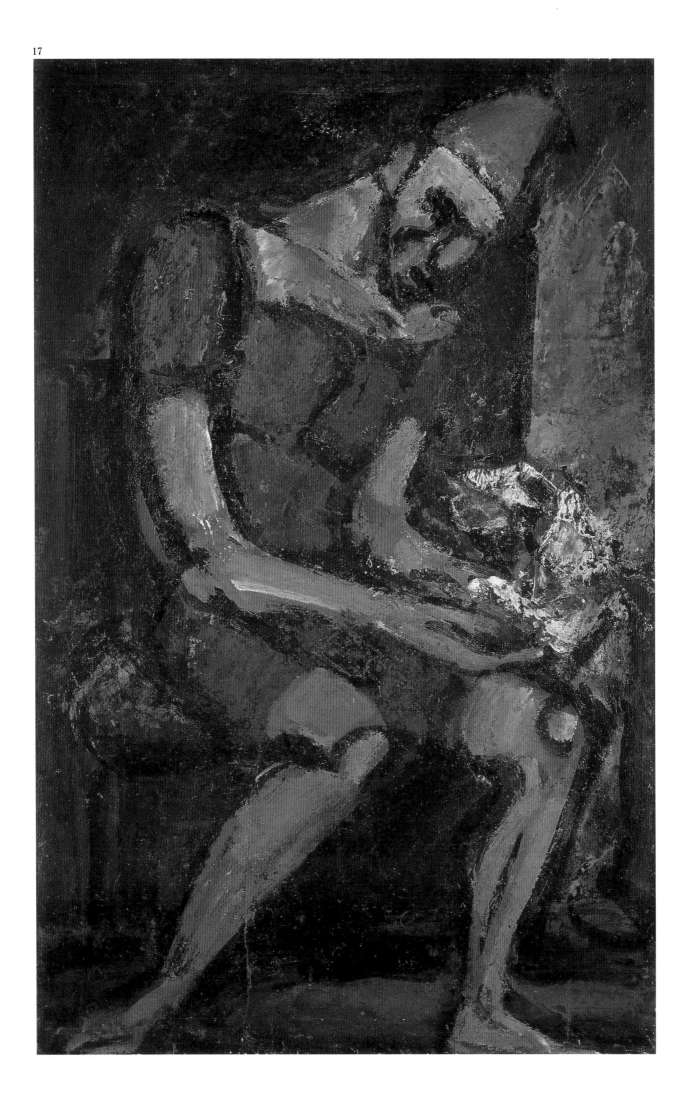

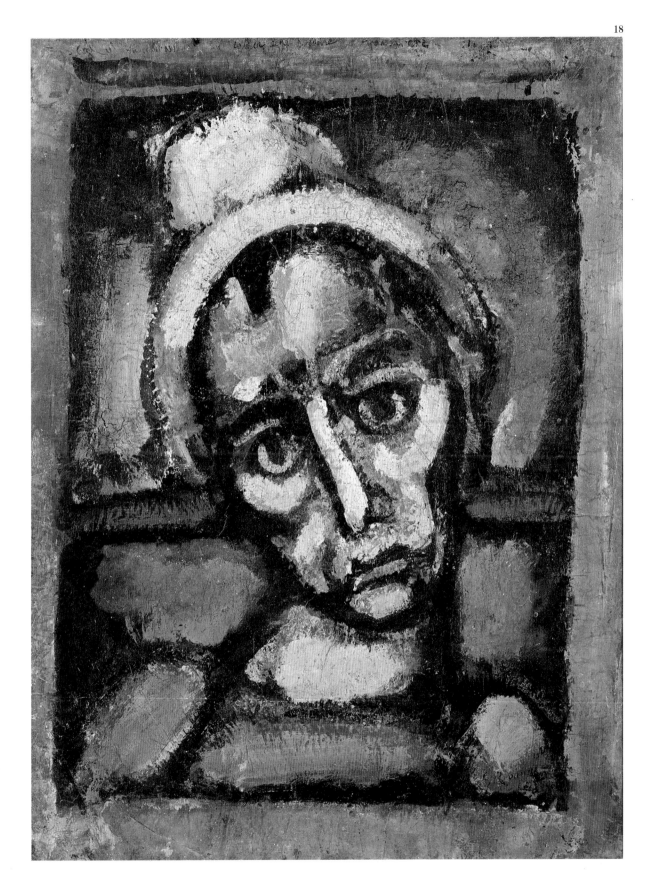

17, 18 Old Clown with White Dog, *c. 1925;* Don't We All Wear Makeup? *after 1930. It is
only their rough and abrupt technique that prevents some of Rouault's works from
falling into sentimentalism. Such is the case with these two paintings. In places, the
color seems to have been applied with the artist's finger or palm.*

19

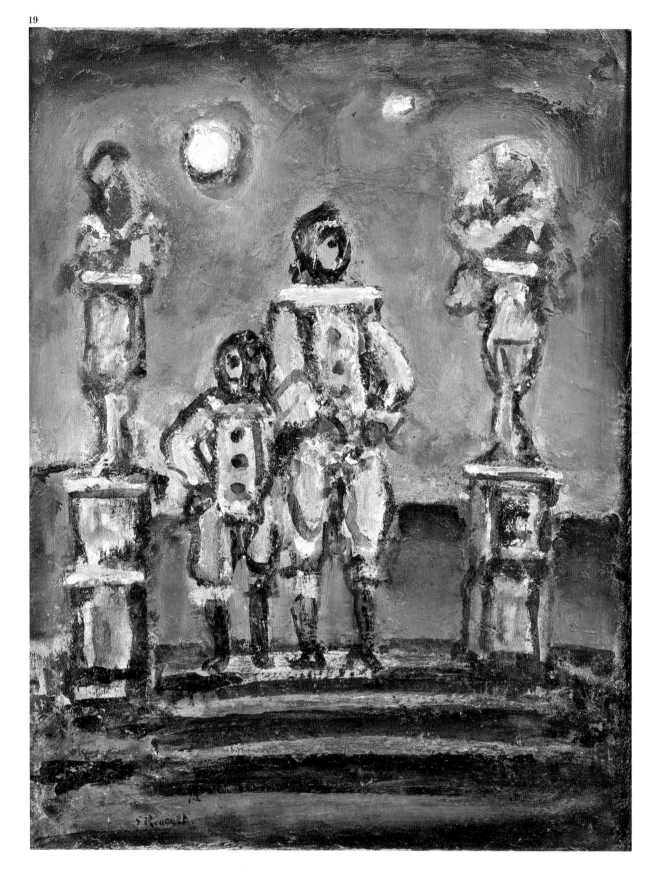

19 Blue Pierrots, *c. 1943. This work shows the transformation that Rouault's painting underwent toward the end of the 1930s. The shift is especially noticeable when this painting is compared with the one at right (plate 20), with its subdued tonalities and tragic action. This undramatic scene, richly painted in sumptuous reds, blues, and yellows, reveals a much more optimistic perspective on life.*

20 The Injured Clown I, *1932. In talking about this large oil painting, the artist once said, "In my view, it is quite possibly as religious as compositions with a biblical theme. To call a work 'sacred art' is not enough to invest it with religious significance."*

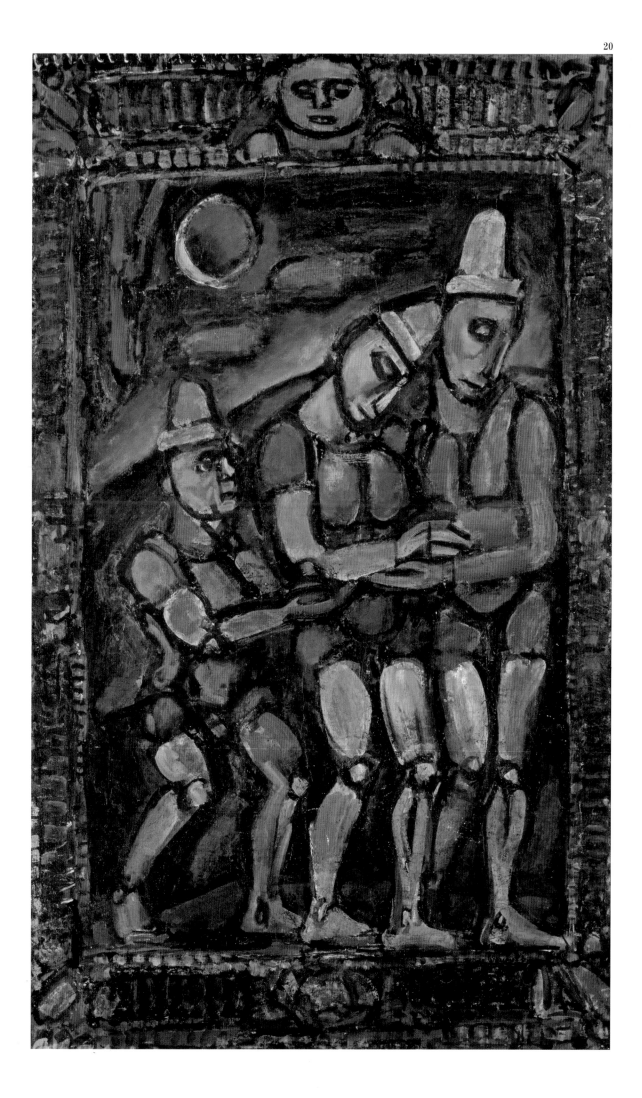

21

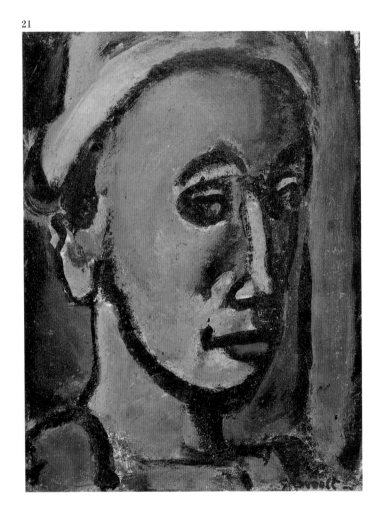

22

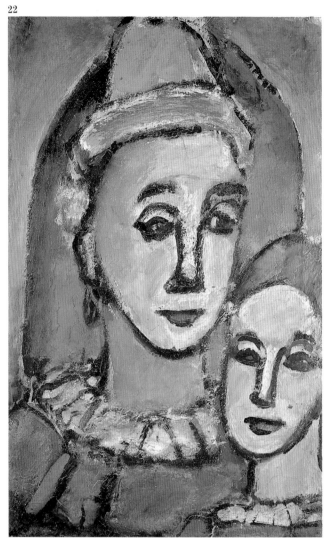

23

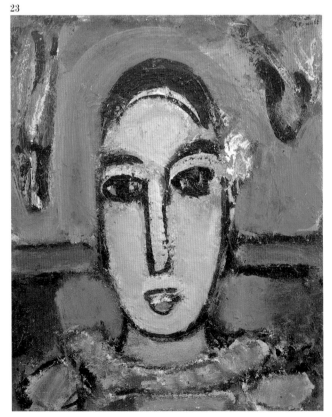

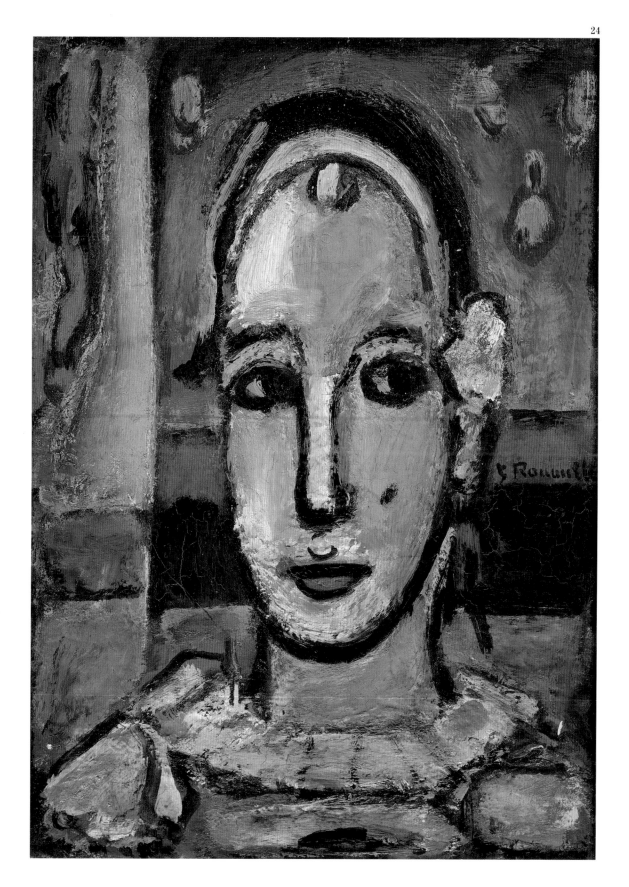

21, 22, 23, 24 Songe Creux *(Dreamer), 1946;* Duo (The Two Brothers), *c. 1948;* Pierrot, *1937–38;* Pierrot, *c. 1948. Toward the end of Rouault's career, the artist painted clowns for their decorative qualities rather than to express any message about human life. The austere male figures that he had painted in the previous decades gave way to a gallery of young pierrots with a certain androgynous air. The chromatic range of these pictures is brighter, and the heaviness of the impasto on the canvas or paper only accentuates the cheerfulness of these later images.*

25

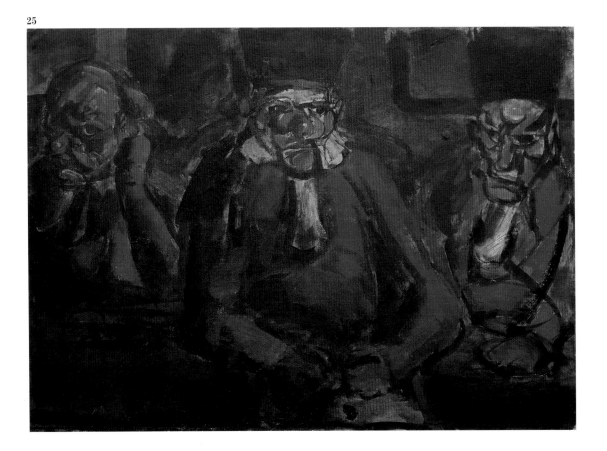

The Human Condition

Rouault's work, filled with images of austere judges and sad, dispossessed outcasts, is often compared with that of the great nineteenth-century social and political satirist Honoré Daumier. Rouault's intentions, however, were quite different from Daumier's. In the first place, his characters are not individuals but types, timeless symbols and reminders of the misery and tragedy of the human condition. Unlike Daumier, Rouault never criticizes society for producing such phenomena as injustice or marginalization, nor does he in any way postulate their demise; he limits himself to observing situations that, he implies, must result from the very nature of things. A good example of this attitude is afforded by Rouault's depiction of courts of law, of which he produced many between 1907 and 1914. According to the painter's own commentary, the ruthless appearance of his judges should not be seen as a token of his condemnation of the system that those same judges are meant to preserve. On the contrary, it stems directly from the sense of anguish that the painter feels when confronted by an individual whose task is to judge others. At times, this deep feeling of distress led Rouault to make a judge's features identical with those of a defendant. The painter summarized this sense of anxiety when he said that "all the riches of the world could not make me take on the position of judge." Rouault's entire life's work betrays a pessimistic resignation, as well as a belief in the universality and inevitability of human suffering.

25 Judges, *1908. The somber view that the artist had of human justice is reflected in the harsh faces of these magistrates. While in Rouault's hands, scenes of courts in session always harbor allegorical intentions, one can also legitimately consider their inherent picturesque qualities, as summed up in the artist's own words: "The black cap and the red robe merge together to form a nice color field."*

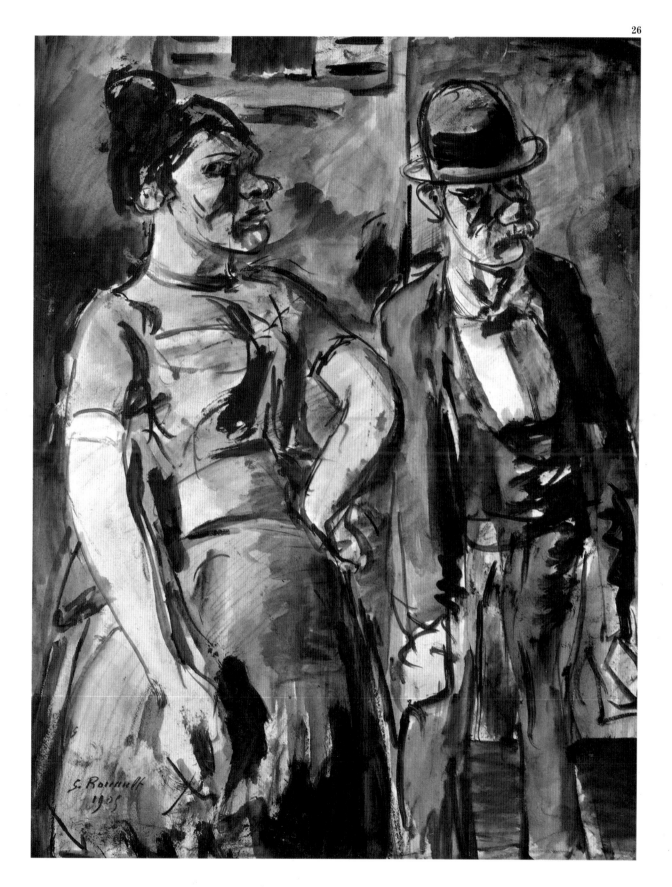

26 The Poulots (The Couple, Red-Light District), *1905. For this watercolor, Rouault drew inspiration from a passage of* La femme pauvre *by the Catholic writer Léon Bloy. Bloy, who saw the finished work at the celebrated Salon d'Automne of 1905, disavowed Rouault's interpretation. After calling Rouault's two figures "monstrous beings," Bloy explained that his own characters were just "a man and a woman, two perfectly bourgeois individuals: candid, peaceful, and compassionate . . . what [Rouault] gave us is two murderers from the slums."*

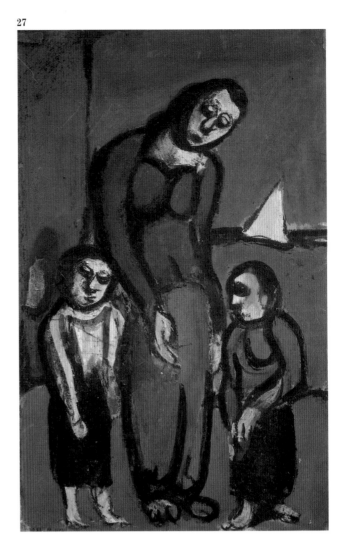

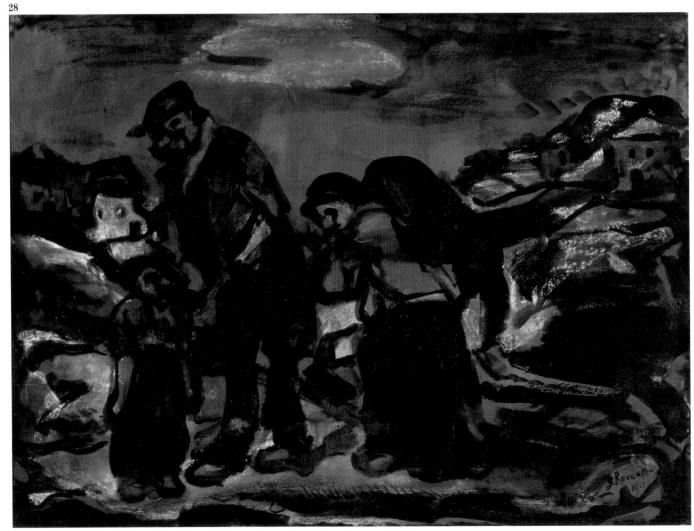

27, 28 Hardships in the Suburbs (A Mother and Her Sons), *1911;* The Fugitives (Exodus), *1911. Owing to his personal recollections of his childhood in the Parisian working-class district of Belleville, Rouault always had a bitter and resigned view of poverty. His indigents do not seem aggressive, like Daumier's, nor do they have the heroic dignity of J.-F. Millet's peasants. They are defeated creatures who bow their heads before a fate that they do not even attempt to fight and who arouse more pity than indignation.*

28

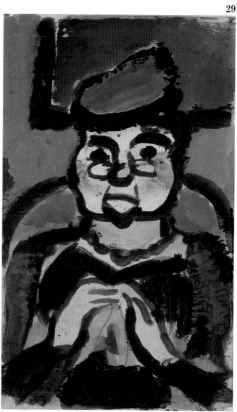

29, 30, 31 Madame X, *1912–13;* Conceit
(The Superman), *1912–13;* La Belle Hélène
*(sketch), 1910–19. These three lesser works
belong in a series executed roughly between
1912 and 1922 in which Rouault
portrayed a gallery of professional and
national types. The caustic sense of humor
that emanates from these pictures led the
critic Apollinaire to compare them to the
Lauds, the simple verses that blend piety
and irony, which Franciscan monks
used to recite in the villages and towns
of Umbria in order to arouse feelings of
charity in their audiences.*

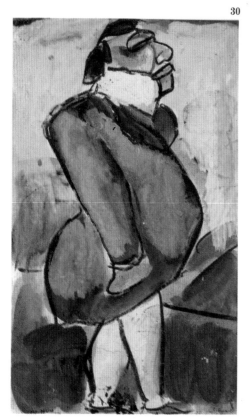

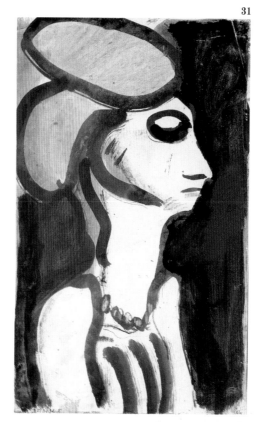

32 The Kindhearted Black (For Ubu), *1918. This drawing belongs to the series of illustrations that Rouault prepared for a book by Ambroise Vollard on Ubu, the outlandish character created by dramatist Alfred Jarry. The assignment originated in 1917, soon after the art dealer had bought the painter's entire atelier, and it initially consisted of India-ink drawings, which were eventually used as the basis of a series of etchings,* Les Réincarnations du Père Ubu.

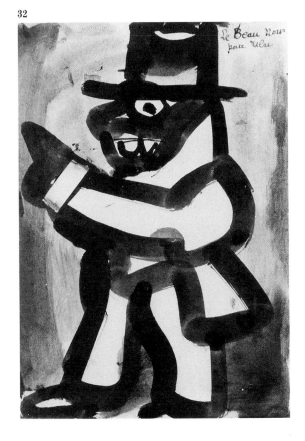

33 At the Hostel, *1914. In this painting, three individuals are shown having a conversation in the hall of a sordid hostel, by the feeble light of an oil lamp that acts as the central axis of the composition. In the background, an opening in the walls of the room reveals a cluster of low houses. The simplicity of the setting, the appearance of the three figures, and their expressive features reflect the hardship of their lives, their miserable status as humble wageworkers.*

33

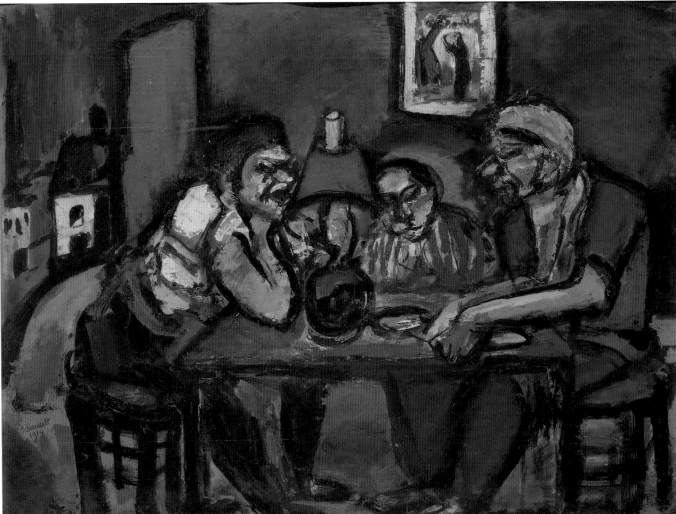

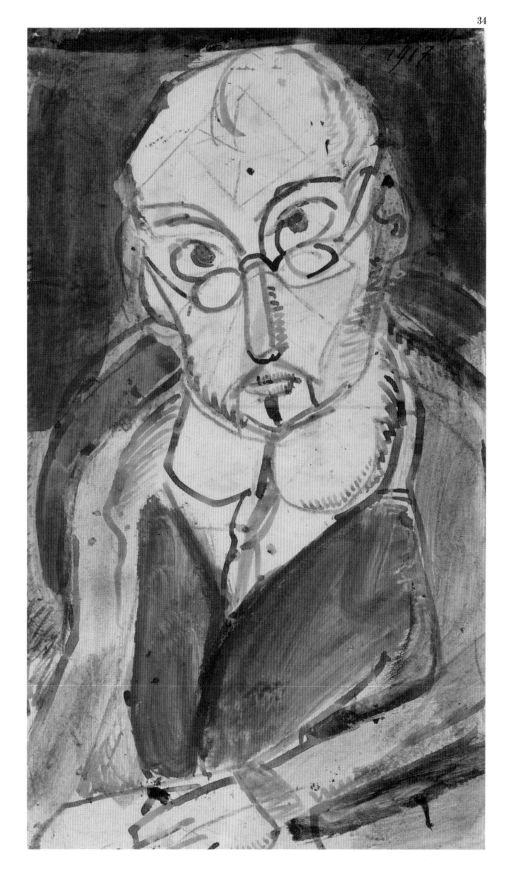

34 Man with Spectacles, *1917.
This inspired example of Rouault's
ability to probe national character
can be compared with Daumier's
caricatures. At the insistence of the
curators of the Museum of Modern
Art in New York, who wanted to
know the identity of the sitter for
one of these paintings, Rouault
allegedly replied, with ill-disguised
weariness, that they were figments
of his imagination. It is difficult
to accept this statement, given the
intense expressivity of this and
other watercolors like it. As a matter
of fact, besides being a keen observer,
Rouault had an exceptionally good
visual memory.*

35

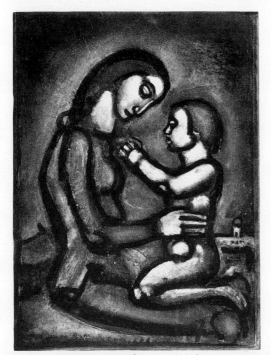

Bella matribus detestata.

36

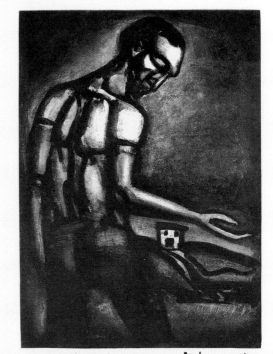

En tant d'ordres divers, le beau métier
d'ensemencer une terre hostile.

37

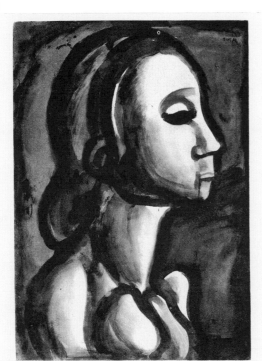

Dame du Haut-Quartier croit prendre
pour le Ciel place réservée.

38

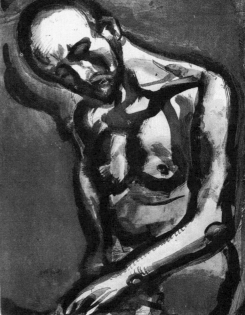

Le dur métier de vivre...

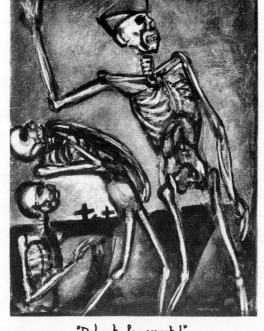

"Debout les morts!"

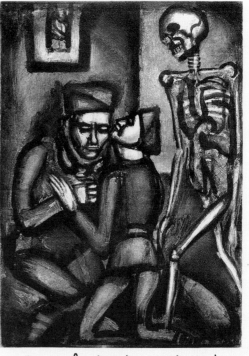

Ce sera la dernière, petit père!

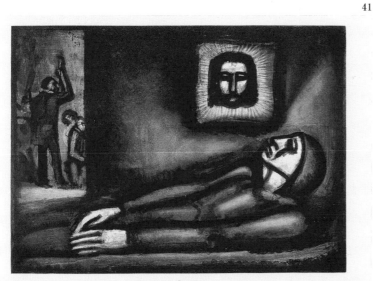

De profundis...

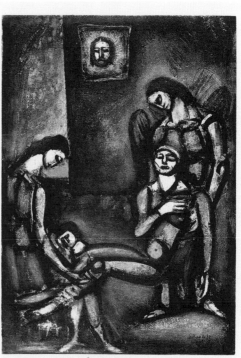

"Le juste, comme le bois de santal,
parfume la hache qui le frappe."

35, 36, 37, 38, 39, 40, 41, 42 Bella Matribus Detestata; In Many Different Respects, the Beautiful Profession of Sowing a Hostile Soil; Lady of High Degree Believes She Has a Place Reserved in Heaven; The Difficult Profession of Living; "Rise, O Dead!"; This Will Be the Last, Little Father; De Profundis; The Righteous, Like Sandalwood, Scent the Ax That Hits Them, *plates from* Miserere, *1917–27. Widely viewed as Rouault's masterpiece*, Miserere *is an album that was originally meant to consist of fifty pictures on the theme of the* Miserere *("Have mercy," the first words of the fiftieth Psalm in the Vulgate, often set to music) and fifty more on that of war. The project, financed by Ambroise Vollard, was later reduced to the fifty-eight etched plates that Rouault had completed by 1927, and it was first published twenty years later, in 1948. The series is an uncompromising denunciation of the horrors of war and, as one of the titles reads, a proclamation of "the difficult profession of living."*

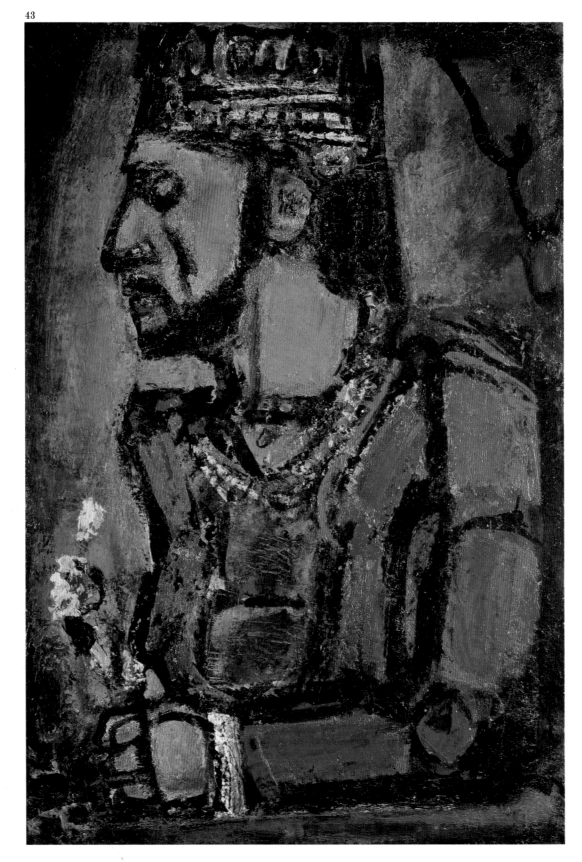

43 The Old King, *1937. This oil painting evokes Rouault's professional beginnings as an apprentice to the stained-glass artists Tamoni and Hirsch. Both the use of intensely bright colors—such as the vivid vermilion—and the pattern of interlaced, thick strokes that looks like brickwork are reminiscent of medieval stained-glass windows, with which the young artist must have become acquainted in Tamoni's and Hirsch's workshops between 1885 and 1890. Like Rouault's prostitutes and clowns, this aging king appears to have suffered in life. The art historian Frederick Hartt observed that Rouault's early moral indignation was transformed in later works like this one, "into a gentler mysticism in some ways reminiscent of Rembrandt."*

44 Homo Homini Lupus *(Man Is a Wolf to Man), 1944–48. Just as the engravings of the* Miserere *series had stemmed from Rouault's disgust at the horrors of World War I, this painting was prompted by the artist's abhorrence of the tragic events of World War II. The maxim by the Roman playwright Plautus painted along the bottom invests the scene with the power of universality. Like Francisco Goya or Pablo Picasso in their pictures with a message of social protest, Rouault was not seeking to depict a specific event but rather to denounce all wars and, ultimately, all forms of barbarity.*

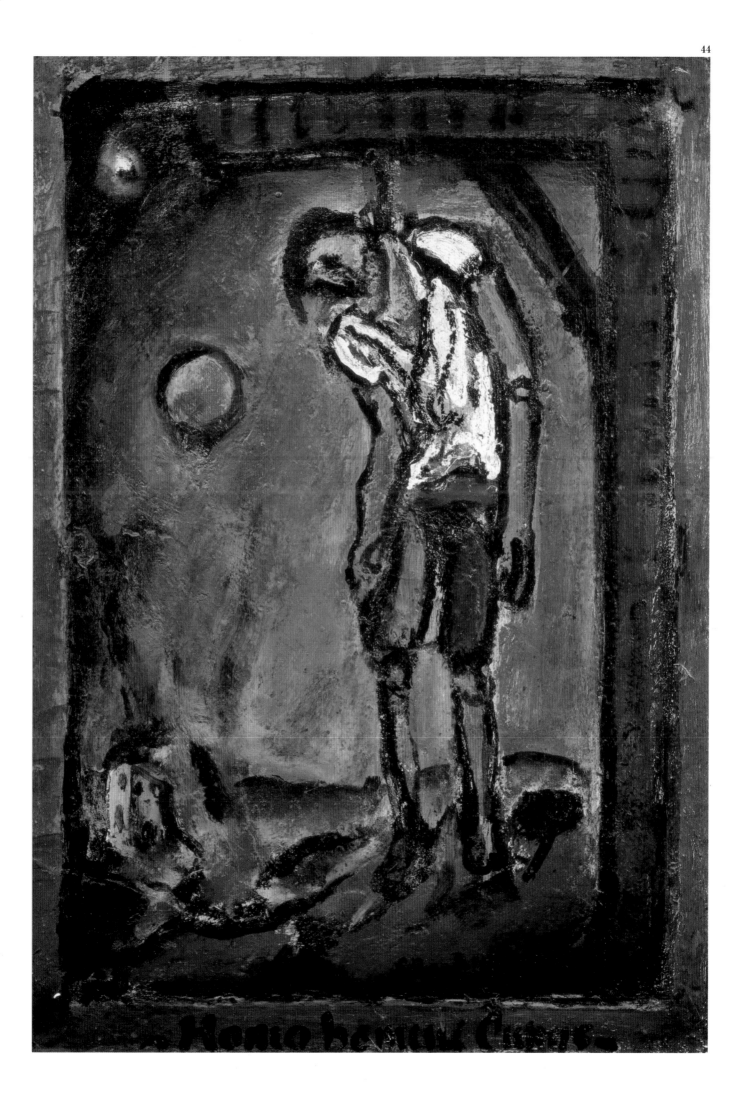

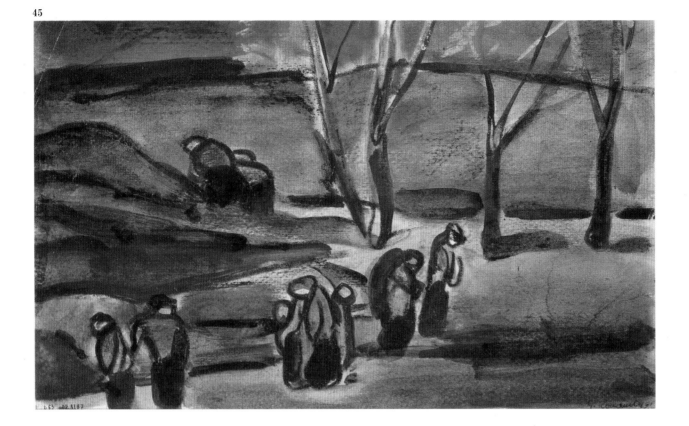

Landscapes and Still Lifes

While the thematic focus of Rouault's work was human existence, his production also contains countless landscapes. They date throughout his career but are especially frequent during the 1930s to the 1950s. In any case, his are thoroughly humanized landscapes, in which figures and architecture play very important roles. The artist never sought to represent any specific physical location in these pictures, as he was more interested in creating a personal view of nature, one that is imbued with a profound feeling of sadness. For the most part, his landscapes are flooded with the warm light of autumnal sunsets—the time of day and of the year most conducive to introspection, the season and the hour when life quiets down and emotions become fraught with melancholy. Bernard Dorival reminds us that, at Moreau's recommendation, Rouault had read A. V. de Vigny, in whose pages he found this bitter statement attributed to Nature herself: "They call me Mother, and I am a tomb." Still lifes did not appear in the painter's production until quite late and they are always exceptional, made in connection with some other task, such as preliminary cartoons for a tapestry, or as a cheerful gift for his wife. These still lifes are all intended as decoration and, as with the landscapes, the images never reflect any specific natural model.

45 Winter III, *1910. The landscape, a desolate stage with no vegetation besides several leafless trees, accentuates the apparent grief of the humans who are moving through it. These stooped creatures walk in a procession, as in traditional representations of an exodus. The fluid brushwork, with its abundant use of paint thinner, gives this little work the appearance of a sketch, almost as if it had been swiftly drafted from life.*

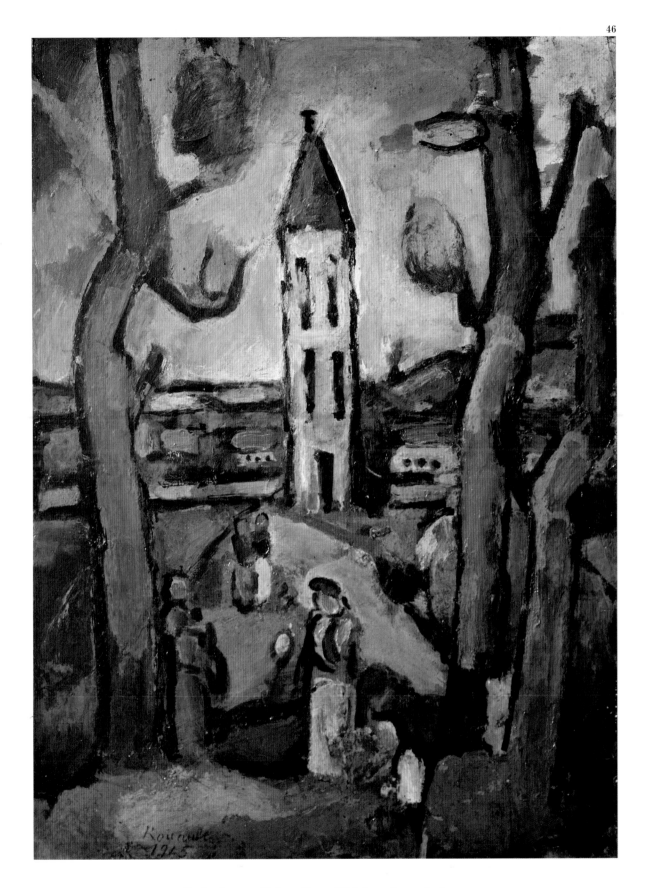

46 Landscape with Large Trees, *1915. Imposing vertical elements—the trees that frame the scene and the bell tower that acts as compositional axis—endow this work with a certain buoyant quality that is otherwise quite infrequent in Rouault's landscapes. The red bands on the tree trunks and the deep blue hues of the vegetation have a certain arbitrariness that is reminiscent of the Fauvist aesthetic.*

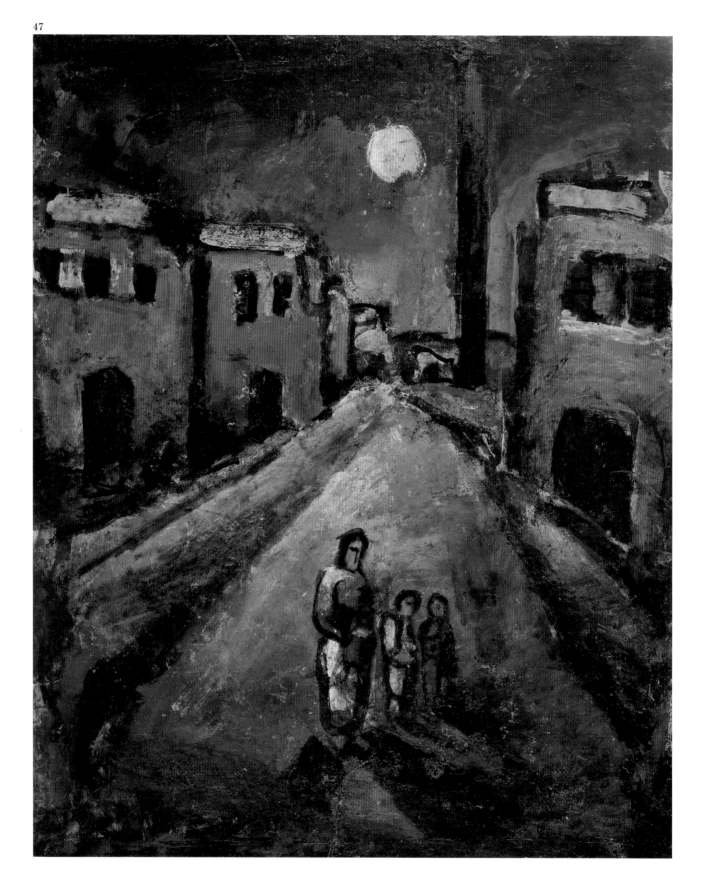

47 Christ in the Suburbs, *1920–24. In this oil painting, Rouault sets a religious story in a modern landscape, a common practice with him in later years. The moon, an almost constant presence in Rouault's "sacred landscapes," centers the composition and casts its dramatic light over the whole scene. Although the illumination creates a striking interplay of shadows evoking Giorgio de Chirico's urban scenes, the conventional yet heartwarming message—Christ is with us in the most desolate places—attests the distance between the intentions of these two early twentieth-century artists.*

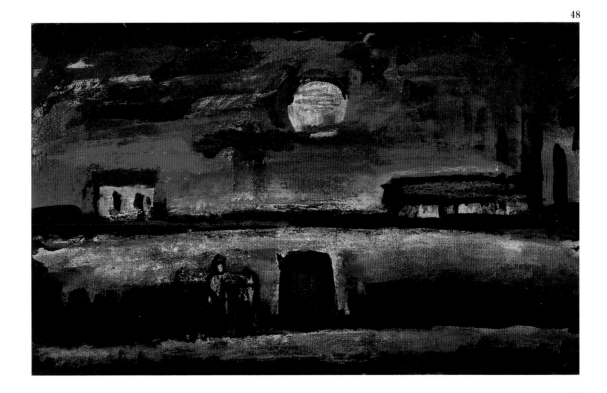

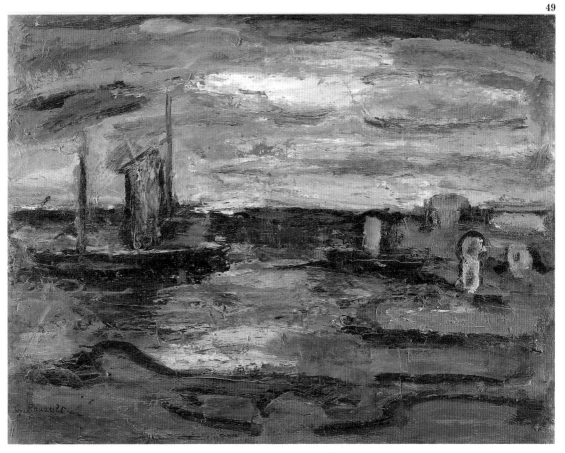

48, 49 " . . . at Nightfall. The Moon Rose," *1930;* Twilight (The Seashore), *1939.*
Comparing these two crepuscular scenes reveals the change that occurred in Rouault's
painting during the 1930s. The chromatic austerity of " . . . at Nightfall"—*the painting*
consists essentially of two stripes of color, interrupted only by the moon and the
buildings, and separated by thick black lines—*contrasts with the chromatic richness*
of Twilight, *on whose surface the painter has vehemently applied a broad palette of*
colors, dominated by warm tonalities.

50

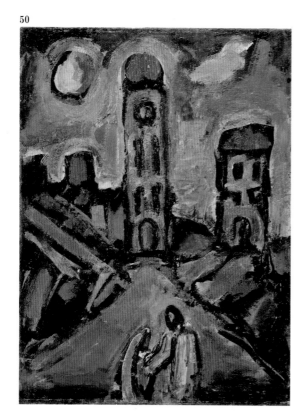

51

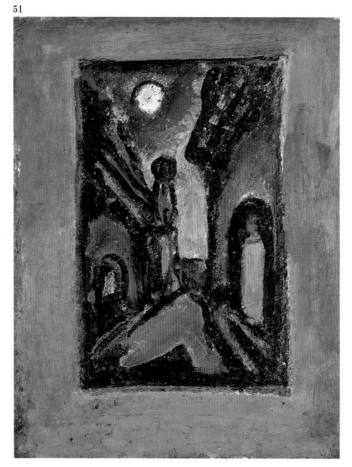

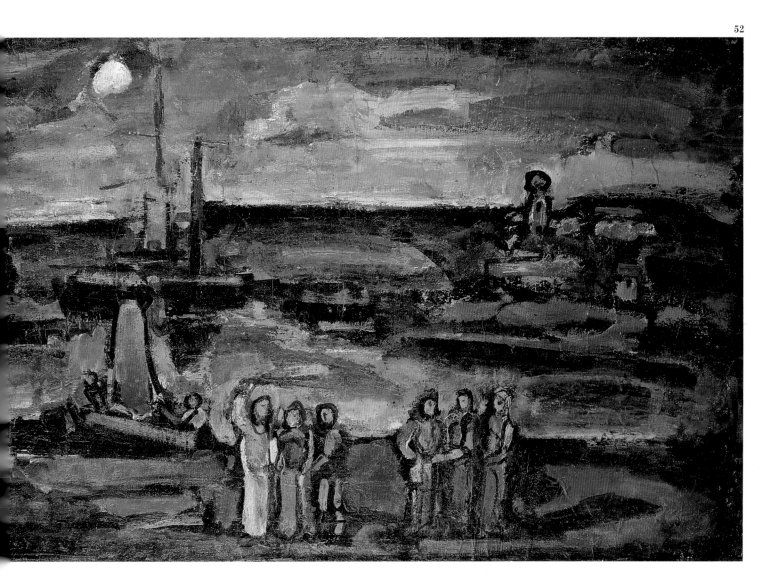

50, 51 Sunset, *1937–39;* " . . . This Desert Street Bordered by Two Palaces," *1935–36.*
Architecture is the protagonist of these two landscapes dominated, once again, by a
luminous moon. Both are fictional landscapes and probably were intended as ideal
images of the Holy Land.

52 Christ and the Fishermen, *1937. Rouault always disavowed any association with*
Impressionism, claiming instead for his work a kinship with the classic French
landscape tradition, namely, with such painters as Nicolas Poussin or Claude
Lorrain. This ambition of his is quite evident in the serene composition of this harbor
scene, in which natural features, architectural elements, and human figures form a
tightly knit, balanced whole.

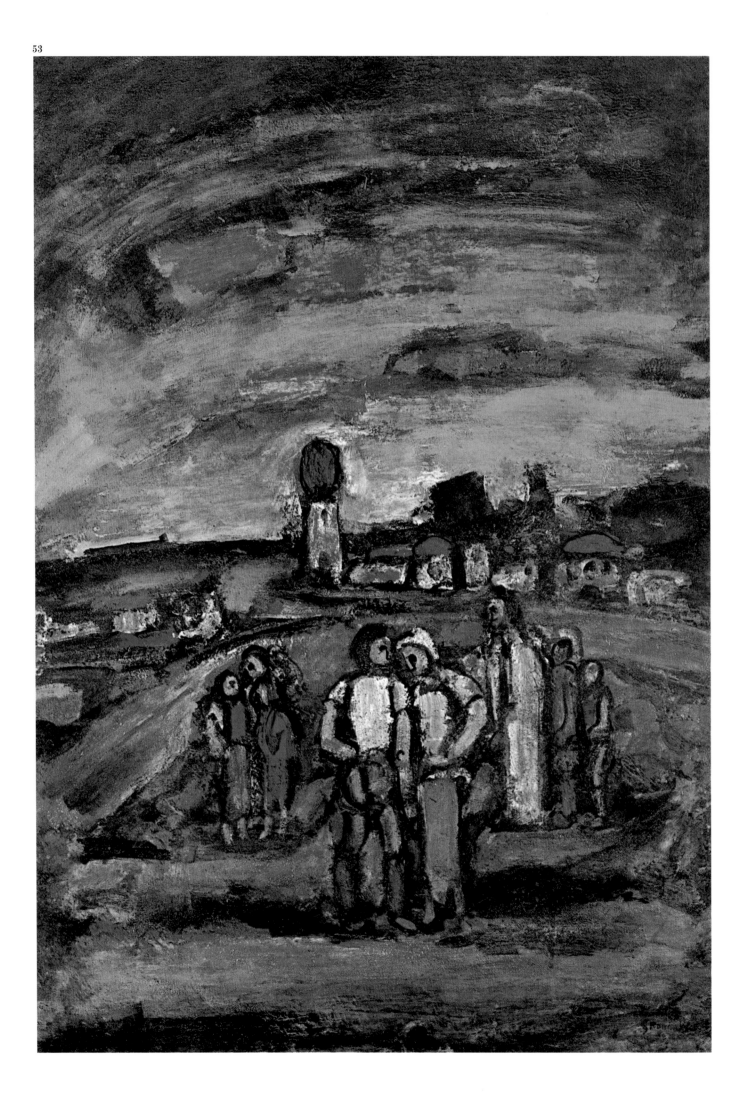

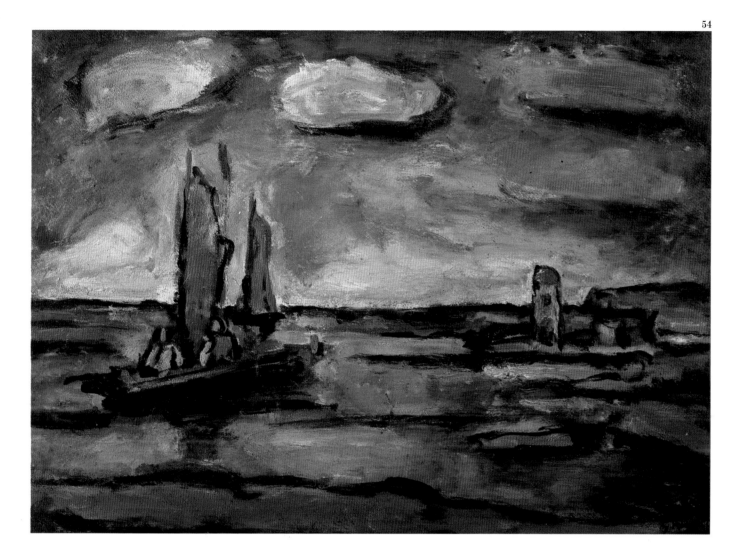

53 Twilight (Île de France), *1937. Most of Rouault's twilight landscapes are melancholy; here, the light of sunset produces a vibrant atmosphere of bright colors. Hues of emerald green, intense purple, and vivid red are applied undiluted with the thick brushstrokes that characterize the painter's mature phase.*

54 Fishing Boat at Sunset, *1939. The ruddy sun—which could be mistaken for the dome of a distant building—bathes the whole scene in a uniform golden atmosphere. The composition is a tightly constructed web of glowing color patches; it has the satisfying orderliness of a stained-glass window, with each element tucked neatly against another.*

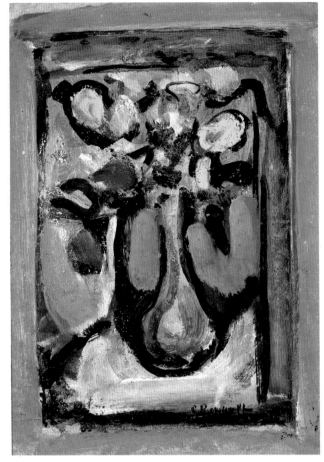

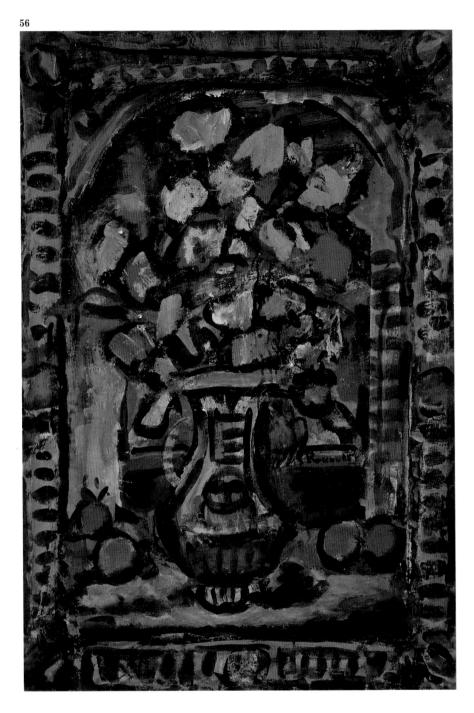

55, 56, 57 Bunch of Flowers in a Yellow Vase, *1939;* Decorative Flowers, *c. 1953;* Decorative Flowers, *1939. Belonging to some botany of the imagination, Rouault's flowers compose sumptuous variegated bouquets. Free of all allegorical intention, these paintings display the artist's talent as a colorist. In all these works, a* horror vacui *(fear of emptiness) seems to affect the painter, who sets his vases in a sort of niche, thereby reducing unfilled space to a minimum.*

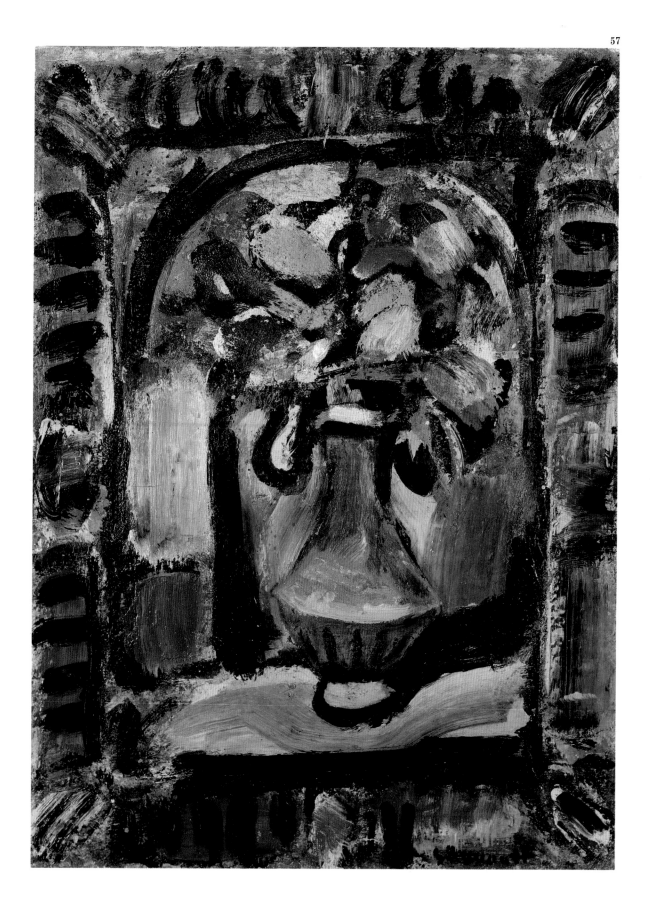

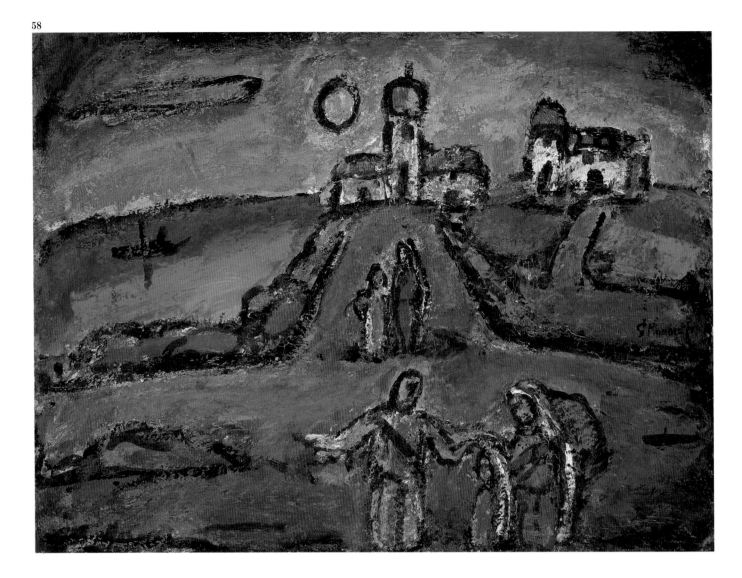

58, 59 Autumnal Night Landscape, *1952; At the End of Autumn III, 1952.*
*The protagonist of both paintings is a central figure with stretched-out
arms, who can be readily identified as Christ. In the backgrounds, a
number of people, seeking his company, are moving toward him. The two
scenes are set in a vaguely Near Eastern landscape, under a moon whose
weak light creates an atmosphere both comforting and mysterious—quite
appropriate to the miracles that Christ is shown performing.*

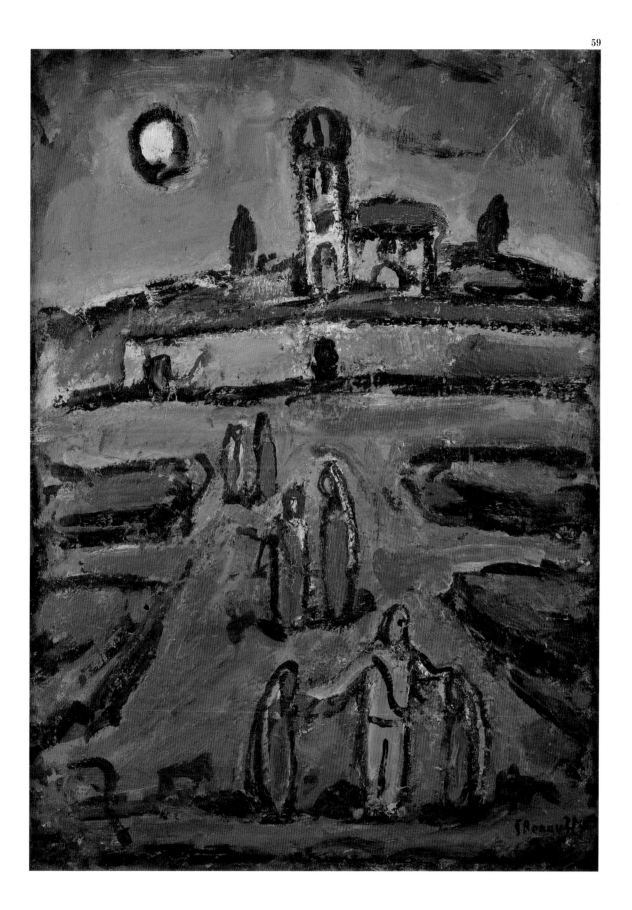

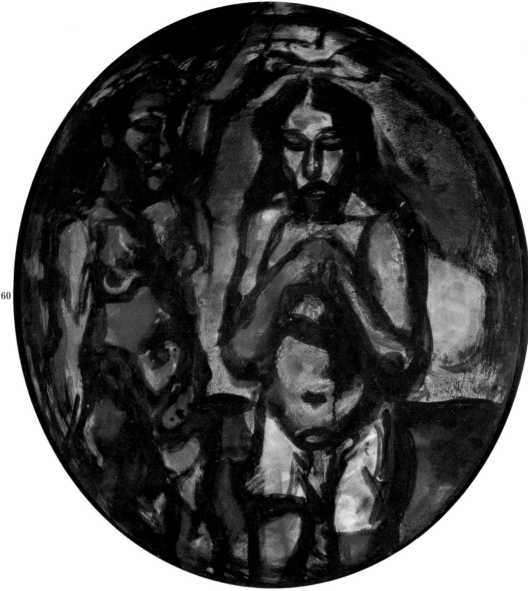

60

Scenes from the Passion

Rouault's first important work was on a religious theme—*The Child Jesus among the Doctors* (1894; plate 2). In the following two decades, religious works were conspicuously scarce in his production, and when, around 1914, they reappeared in large numbers, the characters of the Christian story merely replaced the secular characters who had formerly filled his canvases while conveying the same ideas and values as before. Thus, the sorrows of the mocked Christ echo those of the clown, while the Holy Family takes the place of the small groups of dispossessed outcasts. Despite Léon Bloy's accusation—"If you really were a devout man you would not paint such horrible canvases"—Rouault was always motivated by a deep religious sense. For him, as for many simple and straightforward people, religion was inseparable from all other aspects of life. This explains why he often declared, "There is no such thing as sacred art: there is just art, and that is enough to fill one's lifetime," and why all his works were painted, with a profound sense of humility, in a sort of subdued tone that shuns grandiloquent expression.

60 The Baptism of Christ, *1911. One of the rare works with religious themes that Rouault executed in the years 1900 to 1912, this painting shares its abrupt style with the artist's contemporaneous depictions of prostitutes and clowns (see plates 7, 12). In his commentary on this watercolor, the critic Louis Vauxcelles wrote: "For Rouault, modern humanity is a horde of grubs, of epileptics, and wretched souls. If this acerbic pessimist castigates and distorts his fellow creatures, it is only to throw himself at the feet of a barbaric Christ, whom he represented in a truly unforgettable manner in this Baptism."*

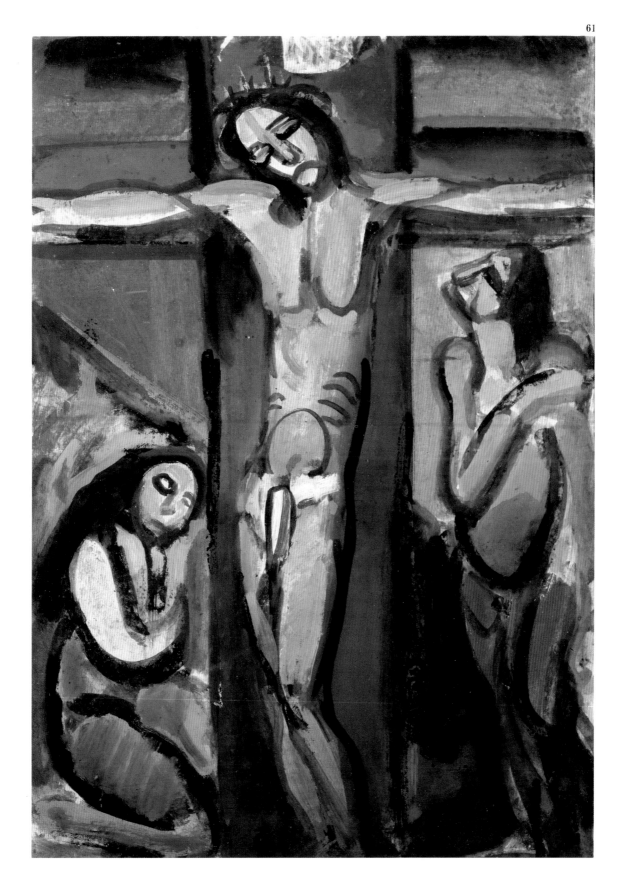

61 Crucifixion, *c. 1914. This gouache is one of Rouault's earliest known Crucifixions. Like the ones to follow, the figure of Christ is placed very close to the viewer, so close that his hands and feet are cut off by the frame.*

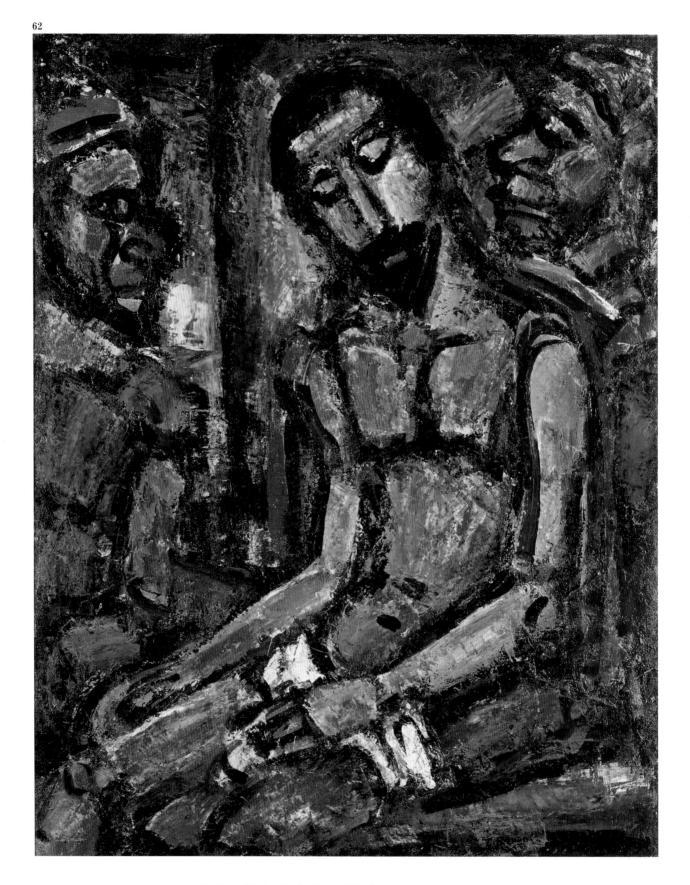

62 Christ Mocked by Soldiers, *1932. Rouault's interpretation of this scene from the Passion of Christ is the exact counterpart of scenes with judges and defendants in courts of law that he depicted during the first decade of the century. The composition of this painting evokes, presumably in an unconscious manner, the countless pictures on the same theme painted by the followers of Caravaggio.*

63, 64, 65 Ecce Homo, *1935–36;* The Mount of
Olives, *1935–36;* Joseph of Arimathea, *1935–36. In
the late 1930s, Rouault executed a series of small
works—all in the same format and with an identical
frame painted by the artist—on the theme of the
Passion of Jesus. Their reduced size and the
schematic quality of the figures represented suggest
popular devotional images. In* Ecce Homo *(Here He
Is) Pontius Pilate, governor of Judaea, presents
Christ, whom he has judged innocent of any crime,
to the people of Jerusalem; in* The Mount of Olives,
Christ is comforted by an angel; in Joseph of
Arimathea, *the dead Christ is seen at the foot of the
Cross with the rich man Joseph, who would bury
him in his own tomb.*

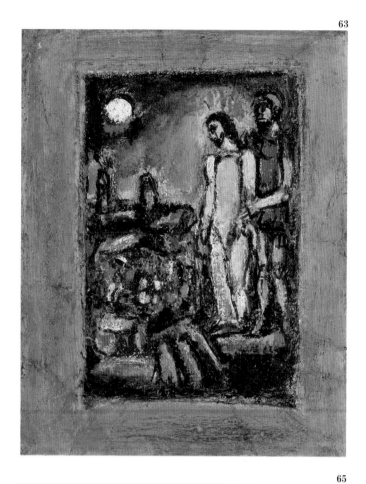

63

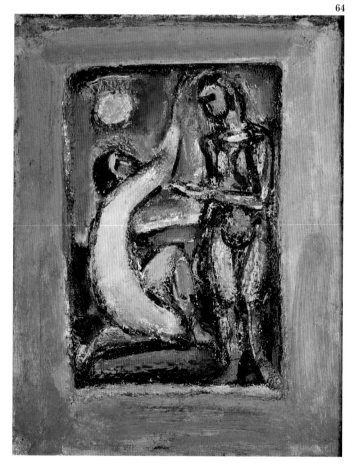

64

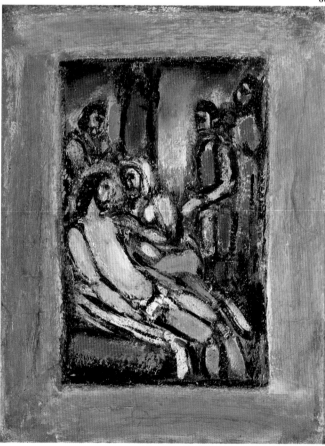

65

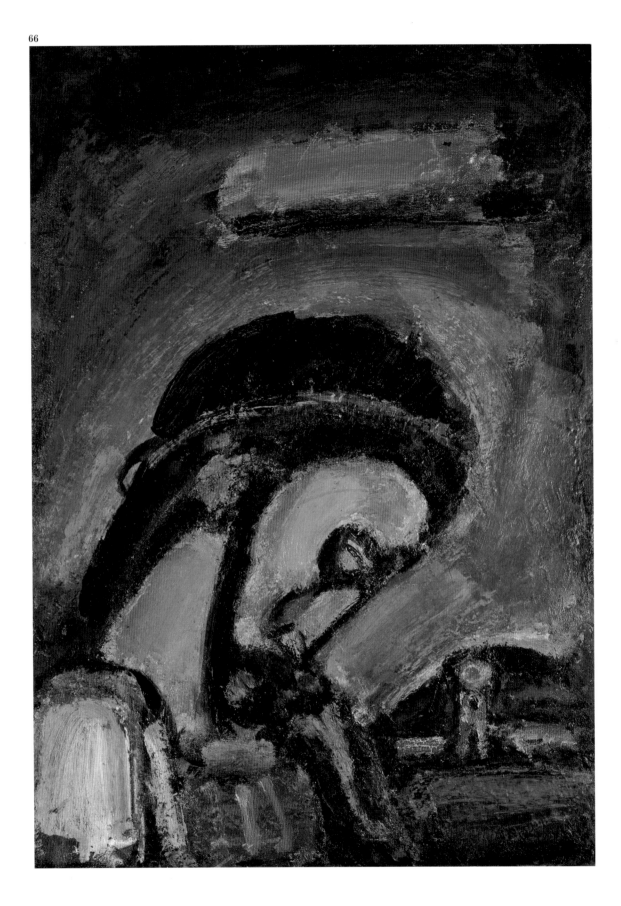

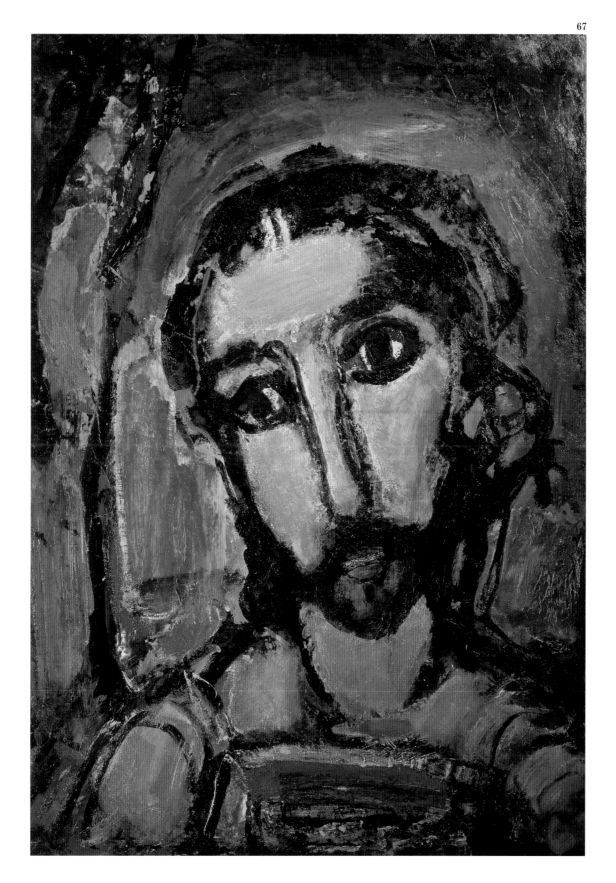

66, 67 Head of Christ, *c. 1937;* Head of Christ (Passion), *1937. As in Byzantine icons, the stylization of these two faces underscores their symbolic function; however, there is no sense of emotional distance here. The intensity of the brushwork counteracts the formality of the image, as does the density of the paint, which thickens around the heads in rippling undulations like emanations of the spirit, or concentrates in fields of intense color.*

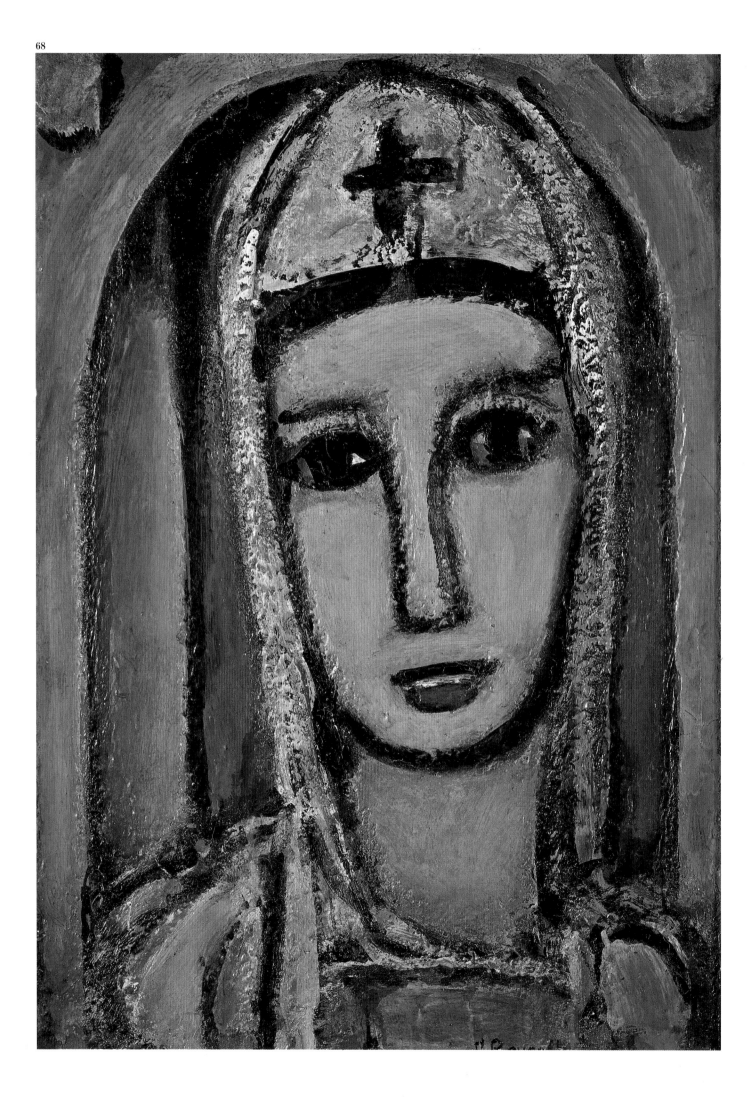

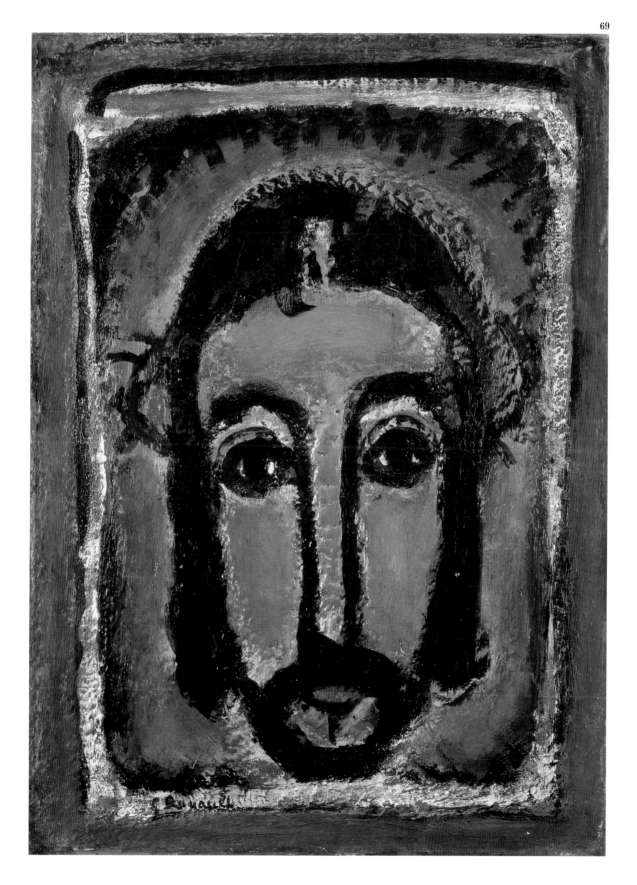

68, 69 Veronica, *c. 1945*; The Holy Countenance, *c. 1946. According to legend, Veronica was the woman who wiped the face of Christ with her veil or a linen cloth as he carried his cross to the place of crucifixion. The cloth, a holy relic preserved in Saint Peter's in Rome, is said to bear the image of Christ's face. Given his belief in the expressive value of the human gaze, Rouault must have found the story of Veronica extremely suggestive. Even more than her celebrated cloth, Veronica's beautiful portrait seems to become a genuine reflection of the countenance of Christ. Rouault also painted the theme of the Holy Countenance— Christ's face, the ideal prototype of all icons—many times, and this version evokes the hieratic quality of Byzantine art.*

List of Plates

1 Night Landscape (The Workyard), *1897. Watercolor and pastel on paper, 24³/₄ × 33¹/₂" (63 × 85 cm). Musée d'Orsay, Paris*

2 The Child Jesus among the Doctors, *1894. Oil on canvas, 57¹/₂× 44⁷/₈" (146 × 114 cm). Musée d'Unterlinden, Colmar*

3 Odalisque, *1906. Watercolor and pastel, 21¹/₄ × 24" (54 × 61 cm). Royal Museum of Fine Arts, Copenhagen*

4 Bathers, *1903. Watercolor on paper, 17³/₈ × 13" (44 × 33 cm). Private collection, Paris*

5 Prostitute at Her Mirror, *1906. Watercolor on cardboard, 28³/₈ × 21⁵/₈" (72 × 55 cm). Musée National d'Art Moderne, Centre Georges Pompidou, Paris*

6 Nude with Arms Raised (Combing Her Hair), *1906. Watercolor, pastel, India ink, and oil, 11³/₄ × 12" (30 × 30.5 cm). Musée d'Art Moderne de la Ville de Paris, Paris*

7 Prostitutes, *c. 1909. Oil, 35³/₈ × 25⁵/₈" (90 × 60 cm)*

8 Nudes, *1914. Gouache or tempera with glue, 20 × 13³/₈" (50.5 × 34 cm). Prague National Gallery, Prague*

9 Pitch-Ball Puppets (The Bride), *1907. Oil, 29¹/₂ × 41³/₄" (75 × 106 cm). Tate Gallery, London*

10 The Conjuror (Pierrot), *1907. Oil and watercolor on paper, 17³/₈ × 13" (44 × 33 cm). Private collection*

11 Bal Tabarin (Dancing the Chahut), *1905. Watercolor and pastel, 28 × 21⁵/₈" (71 × 55 cm). Musée d'Art Moderne de la Ville de Paris, Paris*

12 The Equestrienne (The Female Clown), *1906. Watercolor and pastel on paper, 27 × 20¹/₂" (68.5 × 52 cm). Musée d'Art Moderne de la Ville de Paris, Paris*

13 White Pierrot, *1911. Oil on canvas, 30³/₄ × 25⁵/₈" (78 × 65 cm). Private collection; on deposit at the Kunsthaus, Zurich*

14 Clown, *1912. Oil, 35¹/₄ × 26³/₄" (89.8 × 68.2 cm). The Museum of Modern Art, New York. Gift of Nate B. and Frances Spingold*

15 Acrobat XVI (Wrestler), *1913. Oil and gouache, 41 × 28³/₄" (104 × 73 cm). Private collection, Paris*

16 The Old Clown, *1917–20. Oil, 40¹/₈ × 29⁵/₈" (102 × 75.5 cm). Formerly Stavros Niarchos Collection*

17 Old Clown with White Dog, *c. 1925. Oil, 28³/₄ × 18⁷/₈" (73 × 48 cm). Kiyoharu Museum, Shirakaba, Japan*

18 Don't We All Wear Makeup? *after 1930. Oil and gouache. Indianapolis Museum of Art, Indianapolis*

19 Blue Pierrots, *c. 1943. Oil on paper, mounted on canvas, 23¹/₄ × 17³/₄" (59 × 45 cm). Private collection, Paris*

20 The Injured Clown I, *1932. Oil on canvas, 78³/₄ × 47¹/₄" (200 × 120 cm). Musée National d'Art Moderne, Centre Georges Pompidou, Paris*

21 Songe Creux *(Dreamer), 1946. Oil on paper, mounted on canvas, 13¹/₂ × 10¹/₂" (34.3 × 26.7 cm). Musée National d'Art Moderne, Centre Georges Pompidou, Paris*

22 Duo (The Two Brothers), *c. 1948. Oil on canvas, mounted on panel, 25¹/₄ × 16¹/₂" (64 × 42 cm). Musée National d'Art Moderne, Centre Georges Pompidou, Paris*

23 Pierrot, *1937–38. Oil, 21⁷/₈ × 18¹/₈" (55.5 × 46 cm)*

24 Pierrot, *c. 1948. Oil on canvas, 21¹/₄ × 15" (54 × 38 cm). Private collection, Paris*

25 Judges, *1908. Oil, 29¹/₂ × 41³/₈" (75 × 105 cm). Royal Museum of Fine Arts, Copenhagen*

26 The Poulots (The Couple, Red-Light District), *1905. Watercolor on paper, 27⁵/₈ × 20¹/₂" (70 × 52 cm). Private collection*

27 Hardships in the Suburbs (A Mother and Her Sons), *1911. Paste, tempera, and charcoal on paper, 12¹/₄× 7¹/₈" (31 × 19.8 cm). Musée d'Art Moderne de la Ville de Paris, Paris*

28 The Fugitives (Exodus), *1911. Opaque paint and chalk on cardboard, 17³/₄ × 24" (45 × 61 cm). Kunsthaus, Zurich*

29 Madame X, *1912–13. Poster paint, 12¹/₂ × 7⁷/₈" (31.5 × 20 cm). Musée d'Art Moderne de la Ville de Paris, Paris*

30 Conceit (The Superman), *1912–13. Tempera with glue, watercolor, and charcoal, 12¹/₄ × 7⁵/₈" (31 × 18 cm). Musée d'Art Moderne de la Ville de Paris, Paris*

31 La Belle Hélène *(sketch), 1910–19. India-ink wash, tempera with glue, and pastel, 12¹/₄ × 7¹/₂" (31 × 19 cm). Musée d'Art Moderne de la Ville de Paris, Paris*

32 The Kindhearted Black (For Ubu), *1918. India-ink wash, 10¹/₄ × 7³/₈" (26 × 18.5 cm)*

33 At the Hostel, *1914. Gouache or tempera, 21¹/₄ × 28³/₈" (54 × 72 cm). Prague National Gallery, Prague*

34 Man with Spectacles, *1917. Watercolor and crayon, 11⁷/₈ × 6¹/₂" (29.8 × 16.5 cm). The Museum of Modern Art, New York. Gift of Abby Aldrich Rockefeller*

35 Bella Matribus Detestata, *plate XLII from* Miserere, *1917–27*

36 In Many Different Respects, the Beautiful Profession of Sowing a Hostile Soil, *plate XXII from* Miserere, *1917–27*

37 Lady of High Degree Believes She Has a Place Reserved in Heaven, *plate XVI from* Miserere, *1917–27*

38 The Difficult Profession of Living, *plate XII from* Miserere, *1917–27*

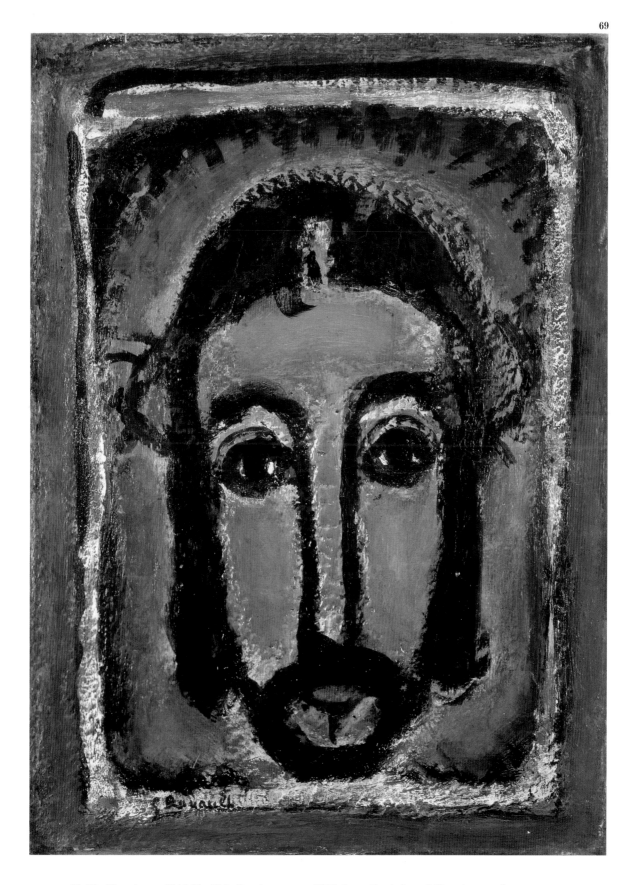

68, 69 Veronica, *c. 1945;* The Holy Countenance, *c. 1946. According to legend, Veronica was the woman who wiped the face of Christ with her veil or a linen cloth as he carried his cross to the place of crucifixion. The cloth, a holy relic preserved in Saint Peter's in Rome, is said to bear the image of Christ's face. Given his belief in the expressive value of the human gaze, Rouault must have found the story of Veronica extremely suggestive. Even more than her celebrated cloth, Veronica's beautiful portrait seems to become a genuine reflection of the countenance of Christ. Rouault also painted the theme of the Holy Countenance— Christ's face, the ideal prototype of all icons—many times, and this version evokes the hieratic quality of Byzantine art.*

List of Plates

1 Night Landscape (The Workyard), *1897. Watercolor and pastel on paper, 24³/₄ × 33¹/₂″ (63 × 85 cm). Musée d'Orsay, Paris*

2 The Child Jesus among the Doctors, *1894. Oil on canvas, 57¹/₂ × 44⁷/₈″ (146 × 114 cm). Musée d'Unterlinden, Colmar*

3 Odalisque, *1906. Watercolor and pastel, 21¹/₄ × 24″ (54 × 61 cm). Royal Museum of Fine Arts, Copenhagen*

4 Bathers, *1903. Watercolor on paper, 17³/₈ × 13″ (44 × 33 cm). Private collection, Paris*

5 Prostitute at Her Mirror, *1906. Watercolor on cardboard, 28³/₈ × 21⁵/₈″ (72 × 55 cm). Musée National d'Art Moderne, Centre Georges Pompidou, Paris*

6 Nude with Arms Raised (Combing Her Hair), *1906. Watercolor, pastel, India ink, and oil, 11³/₄ × 12″ (30 × 30.5 cm). Musée d'Art Moderne de la Ville de Paris, Paris*

7 Prostitutes, *c. 1909. Oil, 35³/₈ × 25⁵/₈″ (90 × 60 cm)*

8 Nudes, *1914. Gouache or tempera with glue, 20 × 13³/₈″ (50.5 × 34 cm). Prague National Gallery, Prague*

9 Pitch-Ball Puppets (The Bride), *1907. Oil, 29¹/₂ × 41³/₄″ (75 × 106 cm). Tate Gallery, London*

10 The Conjuror (Pierrot), *1907. Oil and watercolor on paper, 17³/₈ × 13″ (44 × 33 cm). Private collection*

11 Bal Tabarin (Dancing the Chahut), *1905. Watercolor and pastel, 28 × 21⁵/₈″ (71 × 55 cm). Musée d'Art Moderne de la Ville de Paris, Paris*

12 The Equestrienne (The Female Clown), *1906. Watercolor and pastel on paper, 27 × 20¹/₂″ (68.5 × 52 cm). Musée d'Art Moderne de la Ville de Paris, Paris*

13 White Pierrot, *1911. Oil on canvas, 30³/₄ × 25⁵/₈″ (78 × 65 cm). Private collection; on deposit at the Kunsthaus, Zurich*

14 Clown, *1912. Oil, 35¹/₄ × 26³/₄″ (89.8 × 68.2 cm). The Museum of Modern Art, New York. Gift of Nate B. and Frances Spingold*

15 Acrobat XVI (Wrestler), *1913. Oil and gouache, 41 × 28³/₄″ (104 × 73 cm). Private collection, Paris*

16 The Old Clown, *1917–20. Oil, 40¹/₈ × 29⁵/₈″ (102 × 75.5 cm). Formerly Stavros Niarchos Collection*

17 Old Clown with White Dog, *c. 1925. Oil, 28³/₄ × 18⁷/₈″ (73 × 48 cm). Kiyoharu Museum, Shirakaba, Japan*

18 Don't We All Wear Makeup? *after 1930. Oil and gouache. Indianapolis Museum of Art, Indianapolis*

19 Blue Pierrots, *c. 1943. Oil on paper, mounted on canvas, 23¹/₄ × 17³/₄″ (59 × 45 cm). Private collection, Paris*

20 The Injured Clown I, *1932. Oil on canvas, 78³/₄ × 47¹/₄″ (200 × 120 cm). Musée National d'Art Moderne, Centre Georges Pompidou, Paris*

21 Songe Creux *(Dreamer), 1946. Oil on paper, mounted on canvas, 13¹/₂ × 10¹/₂″ (34.3 × 26.7 cm). Musée National d'Art Moderne, Centre Georges Pompidou, Paris*

22 Duo (The Two Brothers), *c. 1948. Oil on canvas, mounted on panel, 25¹/₄ × 16¹/₂″ (64 × 42 cm). Musée National d'Art Moderne, Centre Georges Pompidou, Paris*

23 Pierrot, *1937–38. Oil, 21⁷/₈ × 18¹/₈″ (55.5 × 46 cm)*

24 Pierrot, *c. 1948. Oil on canvas, 21¹/₄ × 15″ (54 × 38 cm). Private collection, Paris*

25 Judges, *1908. Oil, 29¹/₂ × 41³/₈″ (75 × 105 cm). Royal Museum of Fine Arts, Copenhagen*

26 The Poulots (The Couple, Red-Light District), *1905. Watercolor on paper, 27⁵/₈ × 20¹/₂″ (70 × 52 cm). Private collection*

27 Hardships in the Suburbs (A Mother and Her Sons), *1911. Paste, tempera, and charcoal on paper, 12¹/₄ × 7¹/₈″ (31 × 19.8 cm). Musée d'Art Moderne de la Ville de Paris, Paris*

28 The Fugitives (Exodus), *1911. Opaque paint and chalk on cardboard, 17³/₄ × 24″ (45 × 61 cm). Kunsthaus, Zurich*

29 Madame X, *1912–13. Poster paint, 12¹/₂ × 7⁷/₈″ (31.5 × 20 cm). Musée d'Art Moderne de la Ville de Paris, Paris*

30 Conceit (The Superman), *1912–13. Tempera with glue, watercolor, and charcoal, 12¹/₄ × 7⁵/₈″ (31 × 18 cm). Musée d'Art Moderne de la Ville de Paris, Paris*

31 La Belle Hélène *(sketch), 1910–19. India-ink wash, tempera with glue, and pastel, 12¹/₄ × 7¹/₂″ (31 × 19 cm). Musée d'Art Moderne de la Ville de Paris, Paris*

32 The Kindhearted Black (For Ubu), *1918. India-ink wash, 10¹/₄ × 7³/₈″ (26 × 18.5 cm)*

33 At the Hostel, *1914. Gouache or tempera, 21¹/₄ × 28³/₈″ (54 × 72 cm). Prague National Gallery, Prague*

34 Man with Spectacles, *1917. Watercolor and crayon, 11⁷/₈ × 6¹/₂″ (29.8 × 16.5 cm). The Museum of Modern Art, New York. Gift of Abby Aldrich Rockefeller*

35 Bella Matribus Detestata, *plate XLII from* Miserere, *1917–27*

36 In Many Different Respects, the Beautiful Profession of Sowing a Hostile Soil, *plate XXII from* Miserere, *1917–27*

37 Lady of High Degree Believes She Has a Place Reserved in Heaven, *plate XVI from* Miserere, *1917–27*

38 The Difficult Profession of Living, *plate XII from* Miserere, *1917–27*

39 "Rise, O Dead!" *plate LIV from* Miserere, *1917–27*

40 This Will Be the Last, Little Father, *plate XXXVI from* Miserere, *1917–27*

41 De Profundis, *plate XLVII from* Miserere, *1917–27*

42 The Righteous, Like Sandalwood, Scent the Ax That Hits Them, *plate XLVI from* Miserere, *1917–27*

43 The Old King, *1937. Oil on canvas, 29½ × 20⅞" (75 × 53 cm). Museum of Art, Carnegie Institute, Pittsburgh*

44 Homo Homini Lupus, *1944–48. Oil on paper, mounted on panel, 25¼ × 18⅛" (64 × 46 cm). Musée National d'Art Moderne, Centre Georges Pompidou, Paris*

45 Winter III, *1910. Turpentine paint, pastel, and oil crayons, 7¾ × 12¼" (19.5 × 31 cm). Musée d'Art Moderne de la Ville de Paris, Paris*

46 Landscape with Large Trees, *1915. Oil, 30¾ × 22¾" (78 × 57.5 cm)*

47 Christ in the Suburbs, *1920–24. Oil, 36¼ × 29⅛" (92 × 74 cm). Bridgestone Museum of Art, Tokyo*

48 " . . . at Nightfall. The Moon Rose," *1930. 11¾ × 18⅞" (30 × 48 cm). Antwerp Museum, Antwerp*

49 Twilight (The Seashore), *1939. Oil, 20 × 25⅝" (50.5 × 65 cm). The Phillips Collection, Washington, D. C.*

50 Sunset, *1937–39. 31⅛ × 23½" (79.4 × 59.7 cm).*

51 " . . . This Desert Street Bordered by Two Palaces," *1935–36. Oil, 17⅜ × 13" (44 × 33 cm), including frame. Idemitsu Museum, Tokyo*

52 Christ and the Fishermen, *1937. Oil on canvas, 27 × 50⅛" (68.5 × 127.5 cm). Musée d'Art Moderne de la Ville de Paris, Paris*

53 Twilight (Île de France), *1937. Oil, 40 × 28½" (101.5 × 72.5 cm)*

54 Fishing Boat at Sunset, *1939. Oil, 17¾ × 25¼" (45 × 64 cm)*

55 Bunch of Flowers in a Yellow Vase, *1939. Oil, 13¾ × 9⅞" (34.9 × 25 cm). The Phillips Collection, Washington, D.C.*

56 Decorative Flowers, *c. 1953. Oil on panel, 37½ × 25¼" (94 × 64 cm). Private collection, Paris*

57 Decorative Flowers, *1939. Oil, 17½ × 13" (44.5 × 33 cm)*

58 Autumnal Night Landscape, *1952. Oil, 29½ × 39⅜" (75 × 100 cm)*

59 At the End of Autumn III, *1952. Oil, 41 × 29⅛" (104 × 74 cm). Musée d'Art Moderne de la Ville de Paris, Paris*

60 The Baptism of Christ, *1911. Watercolor and pastel on paper, mounted on canvas, 24¾ × 22⅞" (63 × 58 cm). Musée d'Art Moderne de la Ville de Paris, Paris*

61 Crucifixion, *c. 1914. Gouache and oil on paper, 18⅞ × 13¾" (48 × 35 cm). Formerly, Hahnloser Collection*

62 Christ Mocked by Soldiers, *1932. Oil on canvas, 36¼ × 28⅝" (92.1 × 72.4 cm). The Museum of Modern Art, New York. Given anonymously*

63 Ecce Homo, *1935–36. Oil, 17⅜ × 13" (44 × 33 cm), including frame*

64 The Mount of Olives, *1935–36. Oil, 17⅜ × 13" (44 × 33 cm), including frame. Idemitsu Museum, Tokyo*

65 Joseph of Arimathea, *1935–36. Oil, 17⅜ × 13" (44 × 33 cm), including frame. Idemitsu Museum, Tokyo*

66 Head of Christ, *c. 1937. Oil, 26⅜ × 18⅞" (67 × 48 cm). Private collection*

67 Head of Christ (Passion), *1937. Oil on paper, pasted on canvas, 41⅜ × 29½" (105 × 75 cm). The Cleveland Museum of Art, Cleveland. Gift of the Hanna Foundation*

68 Veronica, *c. 1945. Oil on canvas, mounted on panel, 19⅝ × 14⅛" (50 × 36 cm). Musée National d'Art Moderne, Centre Georges Pompidou, Paris*

69 The Holy Countenance, *c. 1946. Oil, 19⅝ × 14⅛" (50 × 36 cm). Musei Vaticani, Vatican City*

Selected Bibliography

Courthion, Pierre. *Georges Rouault.* New York: Harry N. Abrams, 1977.

Georges Rouault: Exposition du Centenaire. Exhibition catalogue. Paris: Musée National d'Art Moderne, 1971.

Georges Rouault: Paintings and Prints. Text by James T. Soby. Exhibition catalogue. 3d ed. New York: Museum of Modern Art, 1947.

Maritain, Jacques. *Georges Rouault.* New York: Harry N. Abrams, 1952.

Rouault, Georges. *Sur l'art et sur la vie.* Preface by Bernard Dorival. Paris, 1971.

Rouault: Retrospective Exhibition. Exhibition catalogue. New York: Museum of Modern Art, 1953.

Page 1 We Think Ourselves Kings, *plate VII from* Miserere, *1917–27*

Series Coordinator, English-language edition: Ellen Rosefsky Cohen
Editor, English-language edition: Ellyn Childs Allison
Designer, English-language edition: Judith Michael

Library of Congress Catalog Card Number: 96–86829
ISBN 0–8109–4697–1

Copyright © 1996 Ediciones Polígrafa, S.A. and Globus Comunicación, S.A.
Reproductions copyright © VEGAP, Madrid 1996
English translation copyright © 1996 Harry N. Abrams, Inc.

Published in 1997 by Harry N. Abrams, Incorporated, New York
A Times Mirror Company
Printed and bound in Spain by La Polígrafa, S.L.
Parets del Vallès (Barcelona)
Dep. Leg.: 35.280 - 1996